THE ART OF
3D DRAWING

AN ILLUSTRATED AND PHOTOGRAPHIC GUIDE TO CREATING ART WITH THREE-DIMENSIONAL REALISM

BY STEFAN PABST

Quarto is the authority on a wide range of topics.
Quarto educates, entertains, and enriches the lives of our readers—
enthusiasts and lovers of hands-on living.
www.quartoknows.com

6 Orchard Road, Suite 100
Lake Forest, CA 92630
quartoknows.com
Visit our blogs at quartoknows.com

MIX
Paper from
responsible sources
FSC® C101537
www.fsc.org

Printed in China
3 5 7 9 10 8 6 4 2

TABLE OF CONTENTS

Why do we see in the third dimension? How do anamorphic optical illusions work? In order to see a flat, painted object as three-dimensional, we have to trick our senses and our brains using various drawing and painting tricks and techniques. By first drawing subjects on textured surfaces and then adding paint using the drybrushing technique, you can create incredibly realistic 3D artwork. Cutting away excess paper adds to the effect, making it almost impossible to distinguish reality from illusion.

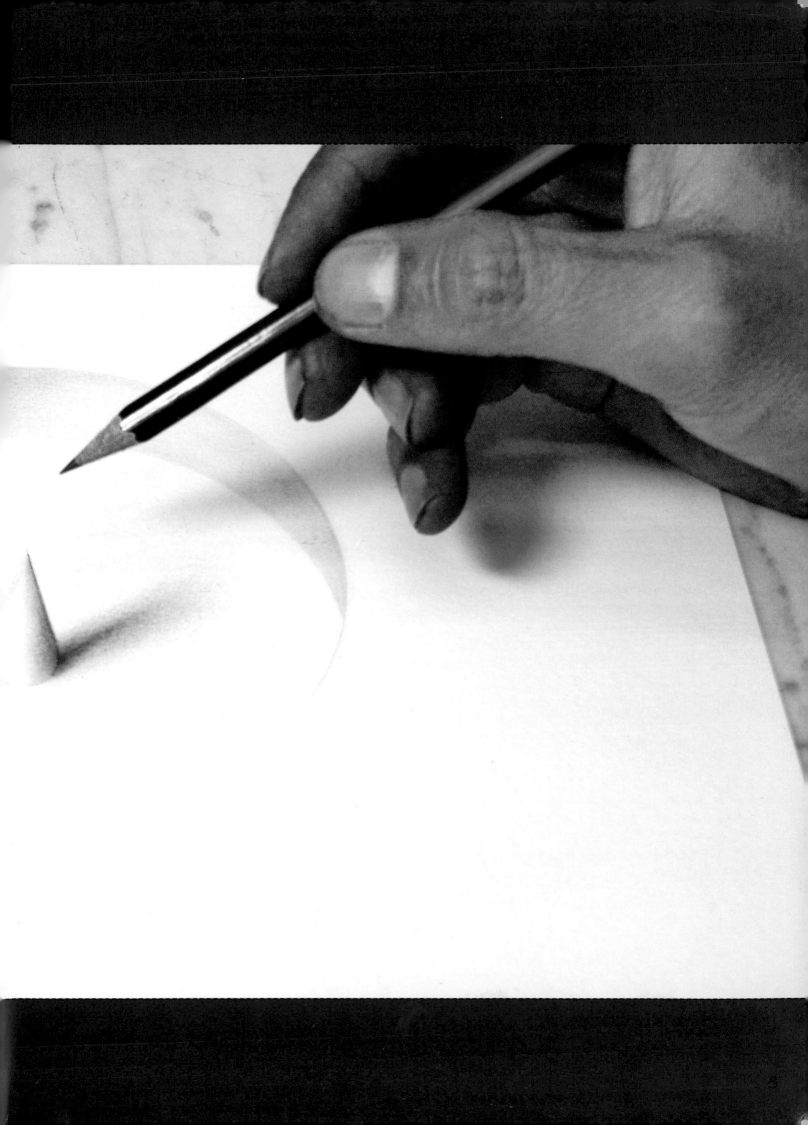

TOOLS & MATERIALS

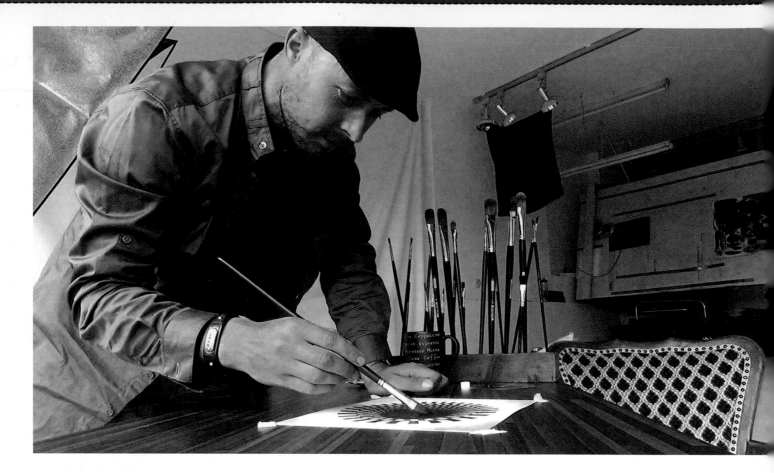

WORK STATION

Set up a work area that has good lighting and enough room to lay out your tools. All you really need is natural lighting. If you draw at night, you can use a soft white lightbulb and a cool white fluorescent light to provide both warm (yellowish) and cool (bluish) light.

DRAWING

HB pencil: I use an HB pencil to draw my subject. A sharpened HB pencil produces crisp lines and offers you good control. If your pencil has a rounded point, you can create somewhat thicker lines and use it to shade smaller areas.

Artist's eraser: This is an essential item for drawing. A kneaded eraser can be formed into a small wedge or point to remove mistakes in tiny areas. Vinyl erasers work well for larger areas and can remove pencil marks completely. Vinyl erasers won't damage your paper unless you scrub them too hard.

Paper: Single sheets of paper work best. Art paper is available in a range of surface textures, from smooth grain (plate and hot-pressed) to medium grain (cold-pressed) and rough to very rough. I use rough paper for the drybrushing technique (see page 16).

ADDING PAINT

Paints: Oil paints are made up of pigments suspended in oils (such as linseed oil) with additives for durability and consistency. Color and consistency vary slightly according to brand, and there are many different quality options. Experiment with various brands, and decide which you like best. Each project in this book lists which colors you will need.

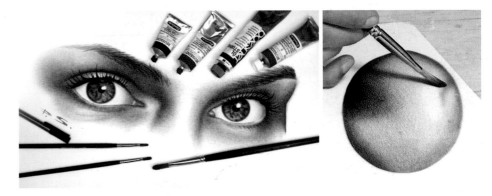

Paintbrushes: Brushes vary in size, shape, and texture. Some are sized by number, and others are sized by inches or fractions of inches. There are four main brush shapes: round, filbert, flat, and bright. *Round brushes* taper to a point and work well for detail work and fine lines. *Filbert brushes* are slightly flattened with long bristles that taper at the tip, so they're good for blocking in large areas and rounding out forms. *Flat brushes*, which have long, rectangular bristles, can hold a lot of paint and work well for creating corners. *Bright brushes* are similar to flat brushes, but they have shorter bristles, which allows for more control. The sharp corners are good for painting thin lines, such as outlines.

Cat's tongue brushes feature a pointed tip in the shape of a triangle. They can create precise strokes and also work well for painting edges and flat areas.

Cleaning your brushes after use will keep them in good condition. Remove as much paint as you can with turpentine, and then wipe the bristles with a paper towel, moving in the direction of the bristles. Then clean them with warm water and gentle dish soap.

Working surfaces: A flat or slightly tilted surface is best for drawing, and an easel is the traditional choice for oil painting.

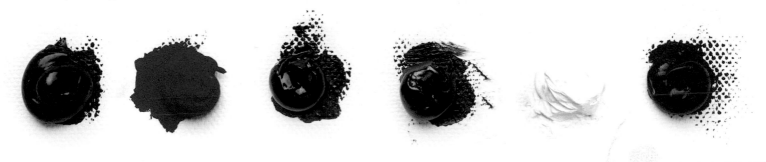

COLOR THEORY & MIXING

Studying a color wheel will help you understand color relationships. Knowing where each color sits on the color wheel shows you how colors relate to and react with one another.

MIXING COLORS

All colors are mixed from the three *primary* colors: red, yellow, and blue. These can't be created by mixing other colors. *Secondary* colors (orange, green, and purple) are each a combination of two primary colors. *Tertiary* colors (red-orange, red-purple, yellow-orange, yellow-green, blue-green, and blue-purple) are created from a mixture of a primary and a secondary color. *Hue* refers to the color itself, such as blue or orange, and *intensity* is the strength of a color.

COMPLEMENTARY & ANALOGOUS COLORS

Complementary colors are any two colors that sit directly across from each other on the color wheel, such as purple and yellow. Analogous colors are adjacent to one another (for example, yellow, yellow-orange, and orange). Analogous colors are similar and create a sense of unity or harmony when used together. To mute a color, or make it subtler and less vibrant, mix in a bit of its complement.

Green · Orange · Purple

Red · Blue · Yellow

COLOR TEMPERATURE

An easy way to understand color temperature is to think of the color wheel as divided into two halves: The colors on the red side are warm, and the colors on the blue side are cool. Colors with red or yellow in them appear warmer.

WARM COLOR WHEEL

This color wheel shows a range of colors mixed from warm primaries. Here you can see that cadmium yellow light and cerulean blue have more red in them (and that cadmium red has more yellow) than do their cool counterparts in the wheel below.

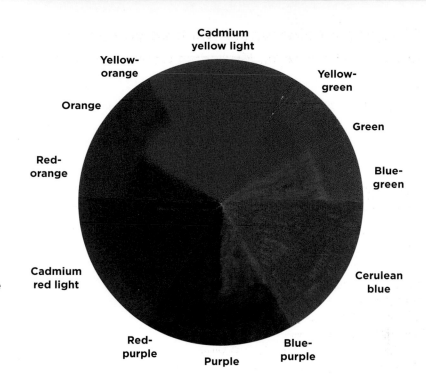

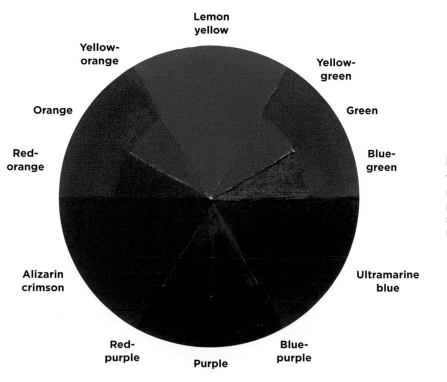

COOL COLOR WHEEL

This cool color wheel shows a range of cool versions of the primaries as well as the cool secondaries and tertiaries that result when they are mixed.

MIXING NEUTRALS

There are few pure colors in nature, so it's important to learn how to neutralize your colors. Direct complements can "gray" each other better than other colors. For instance, if you mix equal amounts of two complementary colors, you get a natural, neutral gray. The chart below shows how to create a range of grays and browns.

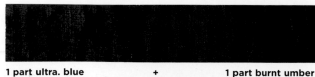

1 part ultra. blue + 1 part burnt umber

1 part alizarin crimson + 1 part ultra. blue = Purple mixture

3 parts
ultra. blue
1 part burnt umber

+
2 parts white

1 part
ultra. blue
2 parts burnt
umber

+
1½ parts white

3 parts
ultra. blue
1 part burnt umber
2 parts
cadmium red lt.

1 part
ultra. blue
1 part
burnt umber
2 parts
cadmium yellow lt.
2½ parts white

1½ parts alizarin
crimson
1 part
ultra. blue
1 part
cadmium yellow lt.

+
1½ parts
white

1 part alizarin
crimson
1 part
ultra. blue
1 part lemon yellow

+
1½ parts white

1 part alizarin
crimson
1 part burnt umber
2 parts cadmium
yellow lt.

2 parts alizarin
crimson
1 part
burnt umber
1 part lemon yellow

TINTING & SHADING

You can mix a wide range of values simply by adding white to a color (creating a *tint* of that color) or by adding black (creating a *shade* of that color). The chart opposite demonstrates some of the tints and shades you can create by adding varying amounts of white or black to a pure color.

TO LIGHTEN A COLOR, YOU CAN ALSO DILUTE IT WITH A SOLVENT, SUCH AS TURPENTINE. SIMILARLY, YOU CAN ADD GRAY TO A COLOR, CREATING A *TONE* OF THAT COLOR.

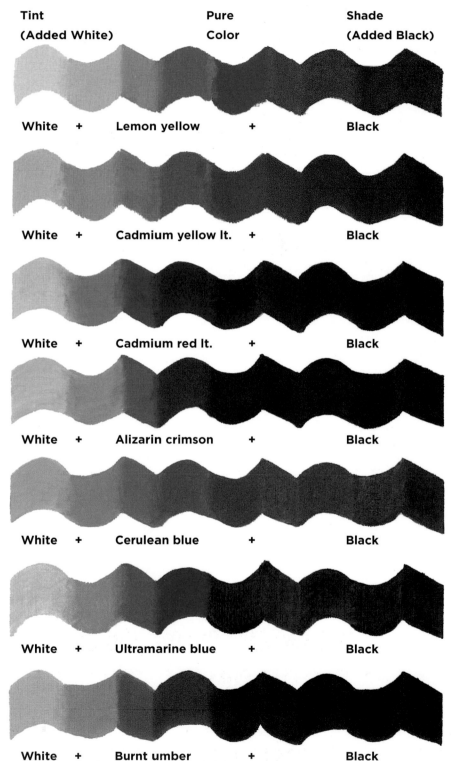

Tint (Added White)		Pure Color		Shade (Added Black)
White	+	Lemon yellow	+	Black
White	+	Cadmium yellow lt.	+	Black
White	+	Cadmium red lt.	+	Black
White	+	Alizarin crimson	+	Black
White	+	Cerulean blue	+	Black
White	+	Ultramarine blue	+	Black
White	+	Burnt umber	+	Black

TO AVOID MUDDYING YOUR COLORS, FOLLOW THESE SIMPLE INSTRUCTIONS. WHEN ADDING WHITE TO A COLOR, ADD JUST A BIT OF THE COLOR ABOVE IT ON THE COLOR WHEEL. FOR EXAMPLE, WHEN YOU ADD WHITE TO RED, ADD A TOUCH OF ORANGE TOO. THIS CREATES A FRESH, LIVELY TINT. WHEN ADDING BLACK TO ANY COLOR, ADD A BIT OF THE COLOR BELOW IT ON THE COLOR WHEEL. WHEN YOU ADD BLACK TO GREEN, ALSO ADD A BIT OF BLUE-GREEN, WHICH CREATES A RICHER, MORE VIBRANT SHADE.

All artists need a solid foundation in drawing to understand form and represent it realistically in 3D. Training your eyes and hands in basic forms will prove valuable, as all objects can be reduced to one of four basic forms: sphere, cube, cylinder, or egg.

VALUE

Each form has five distinct planes, or surfaces: light, halftone or midtone, shadow, reflected light, and highlight. Each form also creates a cast shadow onto a nearby surface. You can represent each of these planes by varying the value of your drawing medium or paint.

VALUE REFERS TO THE LIGHTNESS OR DARKNESS OF A COLOR OR OF BLACK. VARIATIONS IN VALUE CREATE THE ILLUSION OF FORM ON A THREE-DIMENSIONAL SURFACE. ACCURATELY REPRESENTING AN OBJECT'S VALUE PATTERN IS CRUCIAL FOR CREATING A SENSE OF REALISM.

Cast shadow: An object's shadow that is cast upon another surface, such as the table.

Core shadow: The darkest value on an object. It is located on the side opposite the light source.

Midtone: The middle-range value located where the surface turns from the light source.

Reflected light: This light area within a shadow comes from light that is reflected off of a different surface nearby (most often from the surface on which the object rests). The value of this depends on the overall values of both surfaces and the strength of the light, but it's always darker than the midtone.

Highlight: The area that receives direct light, making it the lightest value on the surface.

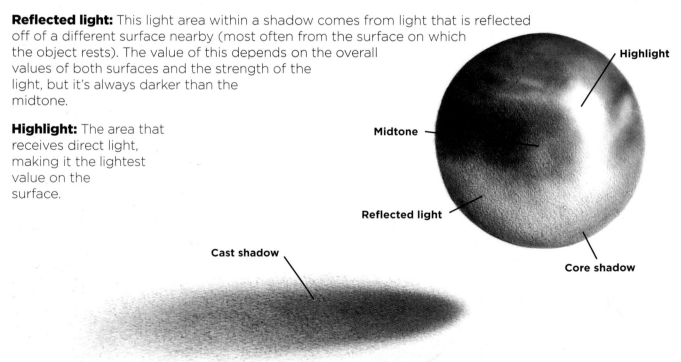

Highlight

Midtone

Reflected light

Core shadow

Cast shadow

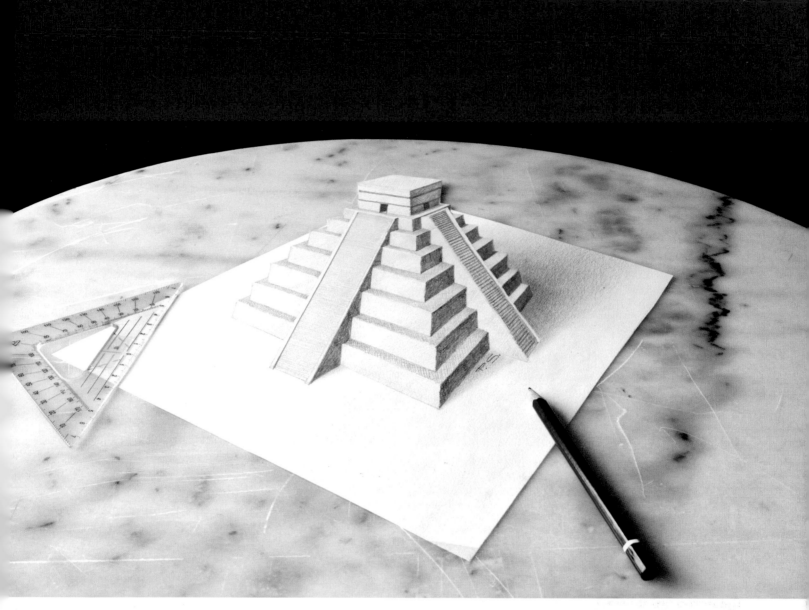

DRAWING WHAT YOU SEE

Humans have stylized ideas of what objects look like, and we often translate these to our drawings and paintings. Once you learn to truly observe an object, you might find that these ideas interfere with your ability to render realistically. Use the exercises below to help train your eye to draw what you really see instead of what you think you see.

NEGATIVE SPACE DRAWING

Draw only the negative space, or the space between the main objects. You'll notice yourself focusing more on the accuracy of shapes than how you think the objects should look, resulting in a more realistic representation.

DRAWING UPSIDE DOWN

Draw from a reference image that has been turned upside down. You'll find that disorienting yourself a bit will bring your focus to the shapes and distract you from any misleading ideas your brain may have.

Negative space drawing

To create 3D drawings and paintings, you will likely use reference photos or the artwork in this book, and copy those onto your drawing surface before adding paint, shadows, and so on. It is very important to get your original drawing right. A couple of tracing or transferring tools can help.

TRACING

A light box is a special desk or an inexpensive box with a transparent top and a light inside. The light illuminates the paper and allows dark lines and shapes to show through for easy tracing. Photocopy or print out a reference image to your desired scale, and place it on the light box, securing it with artist's tape. Then place your drawing paper over the reference, and flip on the switch. The light illuminates the drawing underneath, helping you to accurately trace the lines and shapes onto your new sheet of paper. You can make your own light box by placing a lamp under a glass table, or you can use natural light through a glass window.

TRANSFERRING AN IMAGE

This simple method helps you trace the main outlines of your reference image onto a sheet of paper. First print out your reference at the size you plan to draw it. You can find an image online, or you can use one of the paintings in this book. Then place a sheet of tracing paper over the printout, and trace the outlines. Coat the back of the tracing paper with an even layer of graphite, and place it over a sheet of drawing paper, graphite-side down. (Instead of coating the back of the tracing paper, you can use transfer paper, which already has one side coated with graphite.) Tape or hold the papers together, and lightly trace your outlines with a pencil. The lines of your tracing paper will transfer to the drawing paper below.

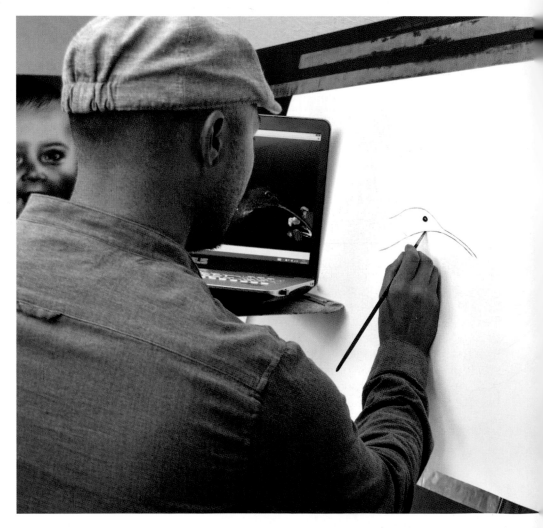

HOW TO ACHIEVE PERSPECTIVE

Perspective is a technique that allows you to represent three-dimensional objects on a flat surface or plane. In art, there are a number of ways to use perspective to obtain the illusion of depth, including using colors and graduated values of black and white, and accurately drawing the subject by applying the rules of the geometric system of perspective.

In order to achieve perspective, you must make a number of observations. The forms or objects that you draw on a flat surface actually have depth and dimension in real life. As you view them and place their shapes and forms on a drawing surface, try to represent that depth to make the objects appear realistic and three-dimensional.

Objects appear differently when viewed from various positions. Because of this, it's important to establish the viewpoint, and stick with it. When observing a subject, you see depth and three dimensions. When you draw this subject onto a flat surface as it appears to the eye, you are drawing in perspective.

KEYHOLE SKETCHING

The "keyhole" sketching method will help you draw an object in front of you. Place the object that you want to paint or draw on a sheet of paper. Then choose the angle that you want to view the object from, such as directly in front of you or from the side.

To help your eyes focus on the object's position on the page, it helps to support your chin on a surface. Depending on the angle, you can rest your chin on a stack of several books, or simply place your chin on your drawing table. The angle from which you see the objects will be even flatter if you place your head lower than the tabletop. View the subject from this angle as you draw it, and the three-dimensional effect will be seen from this viewpoint too.

CROSSHATCHING

Place layers of parallel lines over each other at varying angles. This creates a textured feel. For an added sense of depth, make the lines follow the curves of the object's surface.

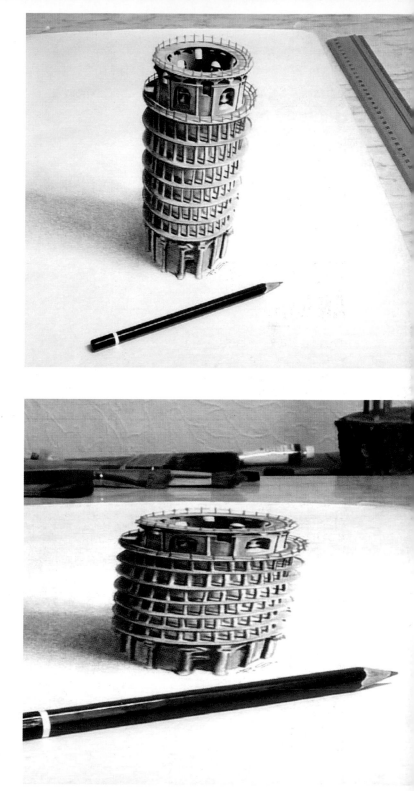

Notice how different this painting of the Leaning Tower of Pisa (see page 98) looks when viewed from different angles.

15

PAINTING TECHNIQUES

When painting with oil, most artists apply paint with brushes. The variety of effects you can achieve—depending on your brush selections and your techniques—is virtually limitless. Experiment to find out what works best for you. A few of the approaches to oil painting and brushwork techniques are outlined below.

Flat Wash: To create a thin wash of flat color, thin the paint, and stroke it evenly across your surface. For large areas, stroke in overlapping bands, retracing strokes when necessary to smooth out the color.

Glazing: You can apply a thin layer of oil over another color to optically mix the colors.

Drybrushing: Load your brush with oil paint, and then dab the bristles on a paper towel or rough sheet of paper to remove excess paint. Drag the bristles lightly over your surface so that the highest areas of the canvas or paper catch the paint and create a coarse texture, scratchy appearance, and irregular effects. This technique also works well to create shadows. I enhance it by drawing and painting onto textured surfaces.

Wet-into-Wet: Applying layers of wet paint to already-wet paint.

Blocking In: The early stages of a painting often involve blocking in the major values, beginning with the midtones. You can paint the midtones as flat masses of tone and color based on the local color of the subject. (Local color refers to the main color of an object, without shadows or highlights; for example, the local color of a lemon is yellow.)

Thin Paint: Dilute your color, and use soft, even strokes to make transparent layers.

Wiping Away: Wipe away paint with a paper towel to create subtle highlights.

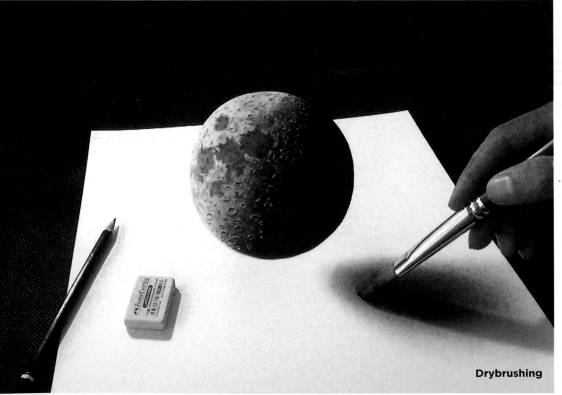

Drybrushing

Thin Paint

Glazing

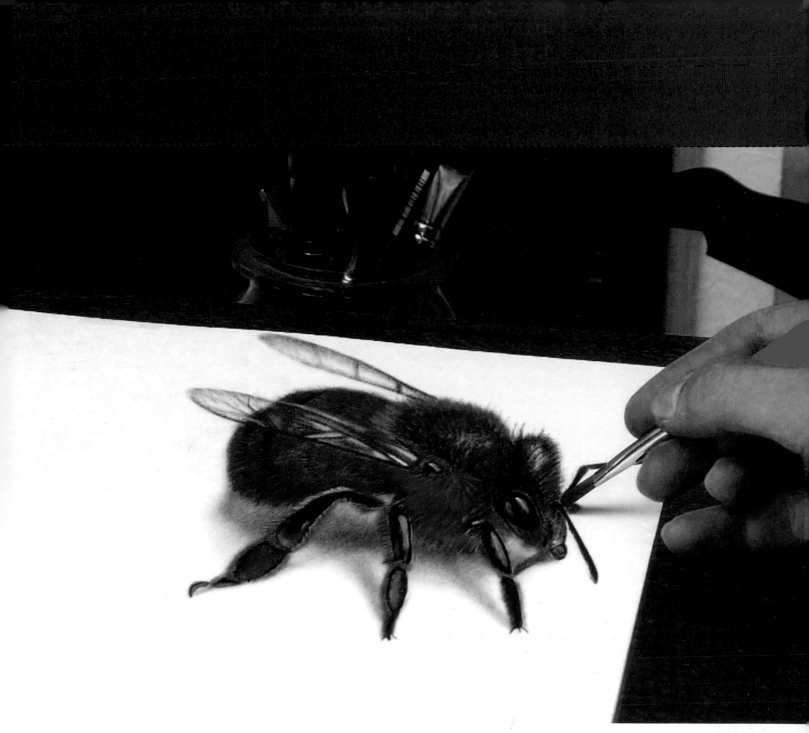

OIL PAINT TAKES A VERY LONG TIME TO DRY. IT CAN TAKE SEVERAL DAYS FOR A LAYER OF PAINT TO FEEL DRY TO THE TOUCH. MAKE SURE TO KEEP A WET OIL PAINTING WELL PROTECTED AS IT DRIES BY STORING IT IN A DARK ROOM WITH LITTLE RISK OF SCUFFING.

Let's begin by drawing a cube. This easy geometric figure will help you understand the principles of three-dimensional drawings and paintings.

MATERIALS

- Tabloid-sized sheet of paper (11 x 17 inches)
- Pencil
- Ruler
- Black oil paint
- Paintbrushes in various sizes
- Eraser

1 OUTLINING

Place the sheet of paper diagonally in front of you, and draw an 8½-inch vertical line with a pencil and a ruler. The bottom end of this line will form the lowest corner of your cube, so mark this spot with a dot. Now move 1¼ inches up from this dot, and draw another dot.

Measure 2 inches to the left, and place another dot there.

Using the vertical line, mark 1½ inches up from the lowest dot. Then place another dot 1⅓ inches to the right.

Draw two diagonal lines to join the dots on the sides with the dot at the bottom.

Go back to the middle line, and place a dot 4½ inches up. Then measure 1½ inches up, and place another dot there. Place a third dot ½ inch up from that spot.

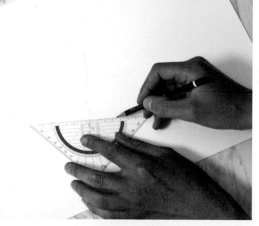

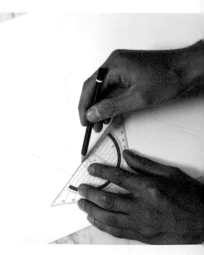

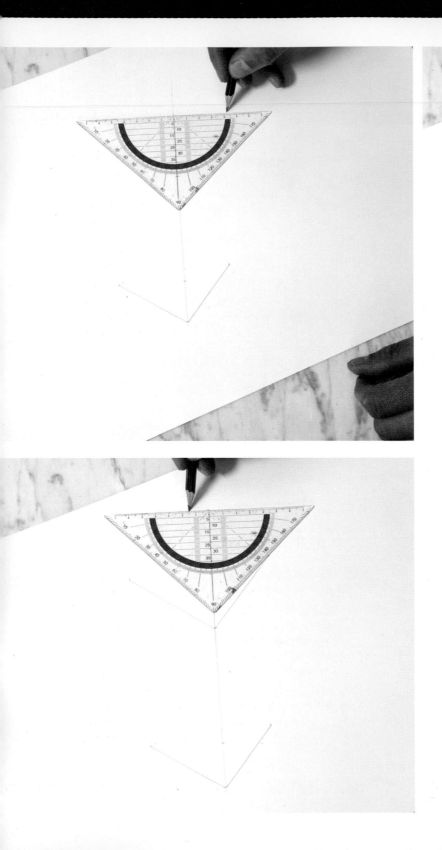

Mark a dot 2⅓ inches to the left of the second dot from the top. Then place another dot 1⅔ inches to the right of the dot at the top.

Draw two diagonal lines to join the dots on the sides with the third dot from the top.

On the vertical line, place another dot 3½ inches above the third dot from the top. Measure ½ inch to the left, and place a dot there. This dot will form the top point of the cube. Draw diagonal lines to join this dot with the dots on each side.

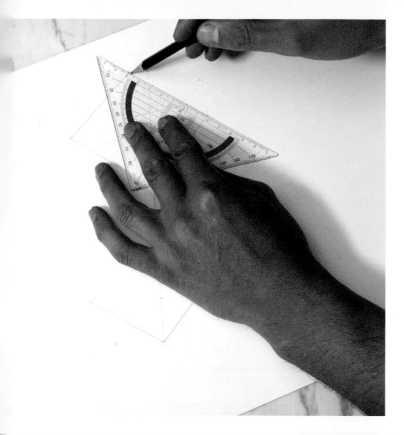

Draw straight lines from the top to the bottom to form the sides of the cube. You should now have a distorted outline, or frame, for your cube.

SHADING

To achieve a realistic 3D effect, you must create natural-looking shading. Here are a couple of tips to help you do this. The shading should match the ambient lighting. For example, if the lighting in the room where you're drawing comes from the window on the left side, you will need to darken the right side of the cube. If you can't tell where the light is coming from, place a square item next to your drawing, and study its shading. Then copy this in your drawing.

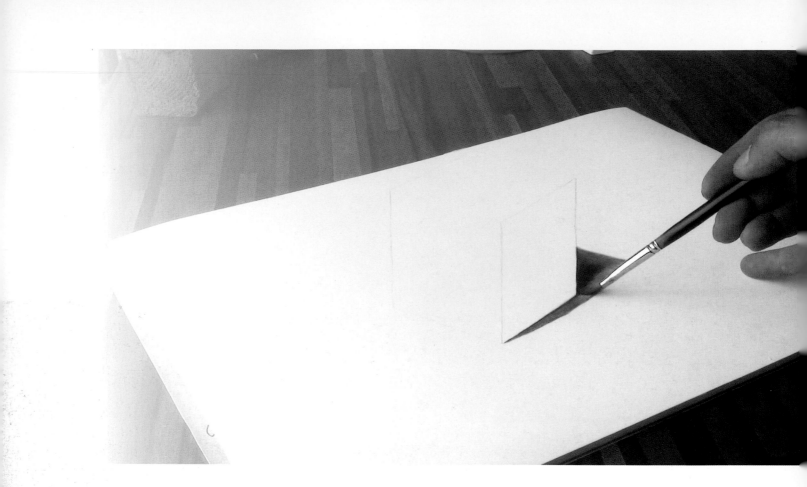

USE DRYBRUSHING TO PAINT DROP SHADOWS. DRY BRUSHSTROKES TYPICALLY LOOK LESS SMOOTH AND SCRATCHIER THAN WASHES AND BLENDED PAINTS.

DRYBRUSHING

To add shading to the cube, start with the darkest part of your drawing: the drop shadow. In my studio, the light comes from the back-left part of the room, so I start with the two sides that face away from the light.

Dip a small brush in black oil paint, and run the brush along the line at the bottom of the cube. Then rub the brush against a rough sheet of paper to remove most the paint. The brush should be relatively dry but still hold some paint.

SMOOTH TRANSITIONS BETWEEN LIGHT AND DARK HELP CREATE A CONVINCING SHADOW.

Grab a wider brush, and dip it in oil paint. Again, rub the brush on a sheet of paper until just a hint of paint appears on the paintbrush.

Paint evenly over the darkest side of the cube, working from dark to light. Use a smaller brush in the corners. Make sure the sides of the cube are painted evenly and without blotches.

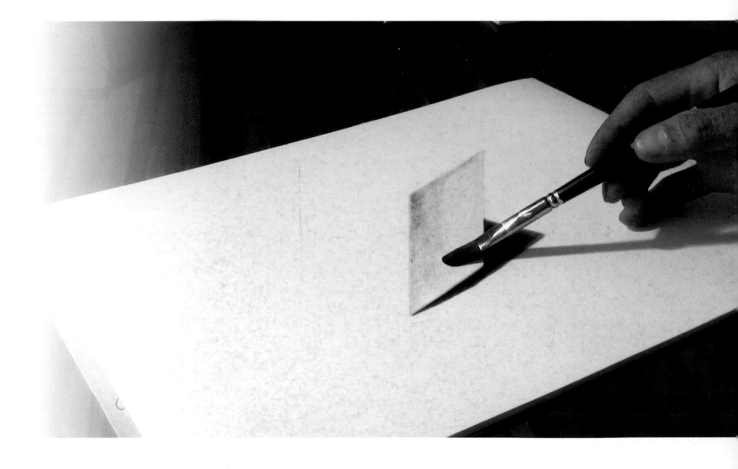

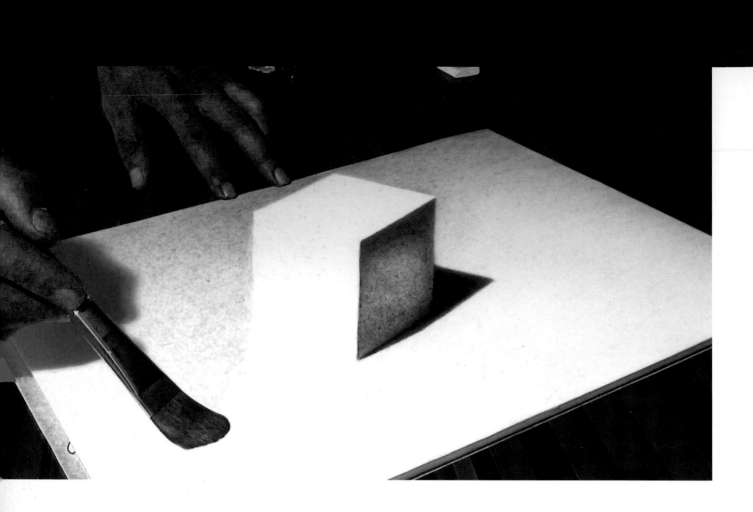

BACKGROUND + REFLECTION

You want the cube to look like it's sitting on the sheet of paper, so the background will need to be darker than the object. This makes the page look like it stretches off into the distance, while the cube stands on top of it. Use the largest brush you have for this step, and drybrush a hint of color around the cube and the edges of the paper. Leave an area in front of the cube white to create a reflection cast by the front of the cube.

Use a small brush to add the finishing touches to your painting, such as reaching into the corners of the cube. The tops of the cube's sides should be shaded a bit darker than the rest.

Rub an eraser over the paint you applied using the drybrushing technique. By running it along the upper edge of the cube, you can add a bit of shine to your artwork.

FINISHING UP

Now take a few steps back, and look at the entire painting. It's easier to spot inconsistencies when you look at a picture as a whole rather than focusing on a single part of it. If you see a flawless optical illusion, you're done!

THE 3D EFFECT WORKS ONLY WHEN YOU VIEW THE IMAGE FROM THE SIDE. IF YOU LOOK AT IT FROM ABOVE, ALL YOU SEE IS A DISTORTED IMAGE.

PROJECT TWO

SPHERE

When painting a geometric figure, you must pay attention to its proportions. Otherwise, the viewer will immediately pick up on any mistakes you've made. This is especially important when creating a sphere. If it's even just a little bit crooked or inconsistent, the proportions won't look right.

MATERIALS

- Tabloid-sized sheet of paper (11½ x 17 inches)
- Pencil
- Black oil paint
- Synthetic cat's tongue brushes in sizes 4 and 12
- Rough sheet of scratch paper

Notice that I didn't draw the sphere in the center of the page. It looks less planned when it's slightly off-center, and the finished sphere will appear to be floating in the air.

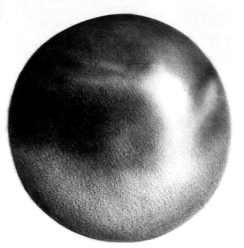

1 | SKETCHING

To sketch out the sphere in pencil, you can use the keyhole method described on page 15, or you can trace my drawing here.

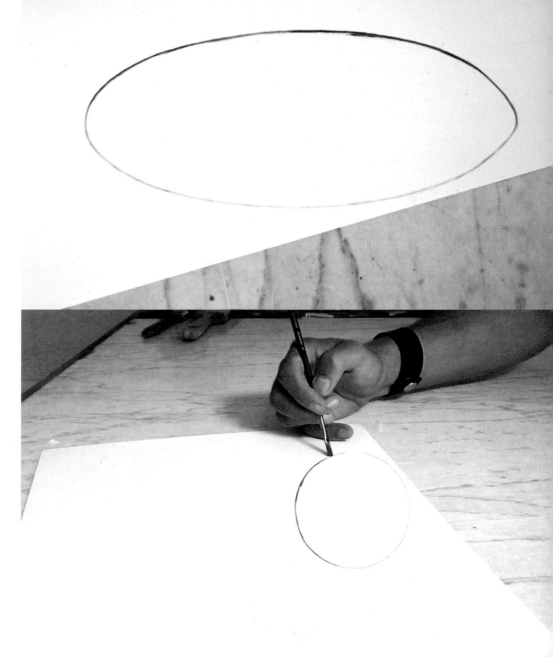

2 | DEFINING THE EDGE

Use black oil paint and the size 4 paintbrush to outline the sketch you just drew. Notice which side of the sphere will feature a shadow, and outline this with a thicker line and more black paint. The other side of the sphere will have a thinner line.

SPHERE

3 SHADING

Shading the sphere as lightly as you can will make it look more three-dimensional and realistic. Using the drybrushing technique (see page 16) creates a gentle transition between light and dark.

With your larger size 12 brush, pick up just a drop of black paint, and rub the brush against a rough sheet of paper to distribute the paint evenly throughout the brush. Then return to the sphere, and place the brush in the area where you want the shadow to appear darkest. Add paint here.

Use sweeping, circular motions to rub paint on the surface of the sphere. Again, you want to create gentle transitions between light and dark, and these movements will help you apply paint evenly.

Place my painting next to yours to see if you've shaded it correctly.

USING A LARGE BRUSH MAKES IT EASY TO ACCIDENTALLY PAINT OUTSIDE THE LINES. TO AVOID THIS, ROTATE THE BRUSH AROUND THE SIDES OF THE SPHERE, DIRECTING YOUR BRUSHSTROKES TOWARD ITS CENTER.

SPHERE

4 THE DETAILS

Large brushes apply paint evenly, so they work well for bigger areas. For details, however, such as along the edge of the sphere, use a smaller brush, such as a size 4 cat's tongue paintbrush. You want to keep the edge of the sphere very sharp.

5 THE DROP SHADOW

Now the sphere looks complete, but it just hangs in the air without a connection to the paper. A real sphere would cast a shadow onto the sheet of paper.

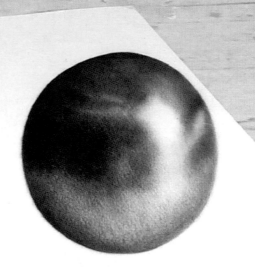

Paint the shadow as softly as you can using the drybrushing technique (see page 16) and a size 12 brush. Place your brush in the middle of the area that will form the sphere's shadow, and shade with light pressure and even, sweeping motions.

The drop shadow should look like an oval, and its edges must transition gently from dark to light. As you shade the shadow, your brush will gradually have less paint on it. You can begin shading the shadow's edges, tapering them outward. As the drop shadow gets closer to the sphere, it should look darker, and its edges can be painted sharper. Everything must look as realistic as possible.

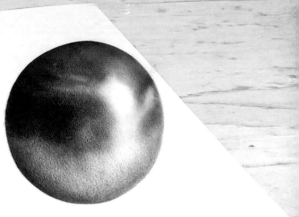

The sphere should look like it's floating in the air, and its shadow will need to be slightly offset rather than directly underneath it.

SPHERE

6 | A PERFECT CIRCLE

If you position the painting correctly, the sphere now looks like a perfect circle. Look at it again, and fix any inconsistencies. Does the sphere look realistic? Is its shadow dark enough?

When I looked at my painting again, I noticed that the edge wasn't quite smooth, so I corrected it with a pencil and drew it sharper.

THE PAINTING IS NOW FINISHED!
HOW DOES IT LOOK TO YOU? DO YOU
SEE A PERFECT SPHERE? SHOW IT
TO YOUR FRIENDS AND FAMILY, AND
ENJOY THEIR AMAZED REACTIONS!

The interplay of light and shadow is very important here.

Unlike some of the other projects that seem to protrude from the page, this project delves into the paper and teaches you to paint a 3D hole. Although the image itself is fairly straightforward, it looks extremely striking. Your goal will be to achieve an effect that makes it look as though the hole actually dips below the surface of the paper. This can be accomplished using realistic shading and a few painting tricks.

MATERIALS

- Pencil
- 8½ x 11 inch drawing or watercolor paper with a moderately rough surface
- Compact disc or other round, traceable object
- Ruler
- Black oil paint
- Synthetic watercolor brushes in sizes 12 and 4

1 DRAWING

With a pencil, draw a vertical line down the center of your sheet of paper. Then grab a round object, such as a CD, place it on the line you just drew, and trace around it to draw a perfectly round circle. Then move the CD down about ½ inch, keeping it on the same line, and draw a semicircle inside the first circle.

Now trace the bottom half of the small circle inside the CD. Use a ruler to draw a cone on top of this semicircle. Here's what your finished drawing should look like:

2 | SHADING

To paint a realistic shadow, the transitions between light and dark must remain soft. Drybrushing with oil paint is the easiest way to do this.

Dip your size 12 brush in some black oil paint, and rub the brush on a sheet of rough paper until the paint no longer smears wet onto the paper. Do this every time you dip your brush into the paint before adding paint to your artwork.

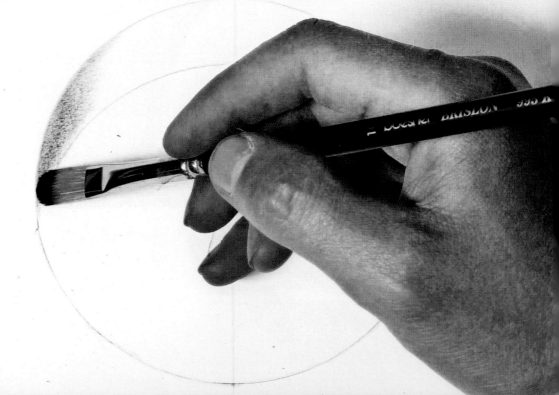

Switch between your
size 4 and size 12
brushes depending
on the area that you
are painting. If you
try to use a small
brush to shade a
large area, the paint
will look less subtle.

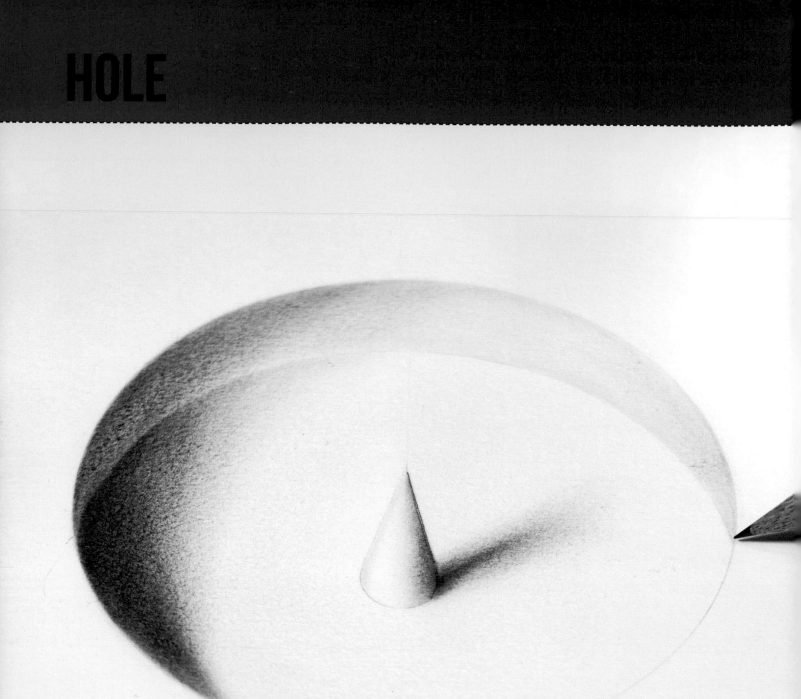

FINISHING UP

Use your pencil
again to draw and
define the edge of
the hole and the
point of the cone.

Now step back, and look at your painting. Does it look 3D? Do you see anything that indicates that the image is actually flat? Maybe something could be darkened? If you've done everything properly, the hole should look real when viewed from the side at an angle of about 45 degrees.

VIEWING YOUR ART FROM A WIDER ANGLE HELPS YOU NOTICE ANY SLIGHT INCONSISTENCIES.

GROUP OF LEGO® BLOCKS

This project uses all of the techniques you've learned so far to create something with a little more color: three Lego® blocks. If you don't have Legos at home, use the photos here to draw and paint.

MATERIALS

- Drawing paper
- Pencil
- Oil paints in red, green, yellow, black, and white
- Synthetic watercolor brushes in a variety of sizes
- Palette

1 DRAWING

Close one eye to focus on the Legos. Rest your chin on a book, look at the sheet of paper, and outline the Legos. Use a ruler if necessary to get their sides really straight. This projects them onto the flat surface, creating an elongated drawing with realistic proportions when viewed from the side.

GROUP OF LEGO® BLOCKS

KEEP YOUR HEAD STILL WHILE SKETCHING, AND DRAW THE OUTLINE AS ACCURATELY AS YOU CAN.

PAINTING

Once you have the outline right, you can sit up again. You need to be able to move your head and view the object from different angles as you paint.

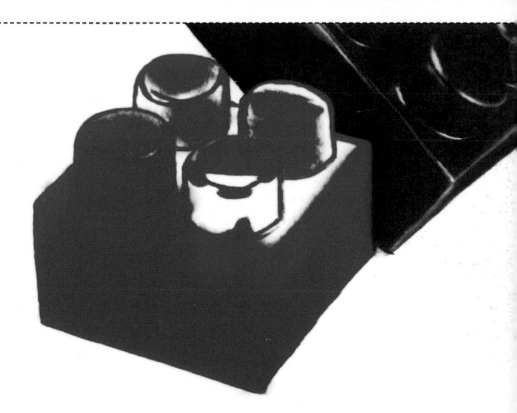

Now paint inside the outlines using the base colors of your Legos (red, green, and yellow in this case). There's no need to add shading yet.

**OIL PAINTS CREATE
A REALISTIC THREE-
DIMENSIONAL PICTURE WITH
NATURAL-LOOKING TONES.**

3 SHADING

Now add a little black paint to each base color. On a palette, mix the two colors until you create one that matches the tone of each Lego's shadow exactly. Dip a brush in paint, and rub the brush across a rough surface until it no longer smears the paint and instead transfers a small amount of paint to the surface.

Then place your brush on the darkest part of the shadow, and applying light pressure, brush the paint evenly to create shading on each Lego. If you use a clean brush to add paint to a light area, you will produce blotchy or even full strokes of paint. Apply the paint evenly to make the Legos look vivid and realistic.

**APPLY SHADING FROM
DARK TO LIGHT.**

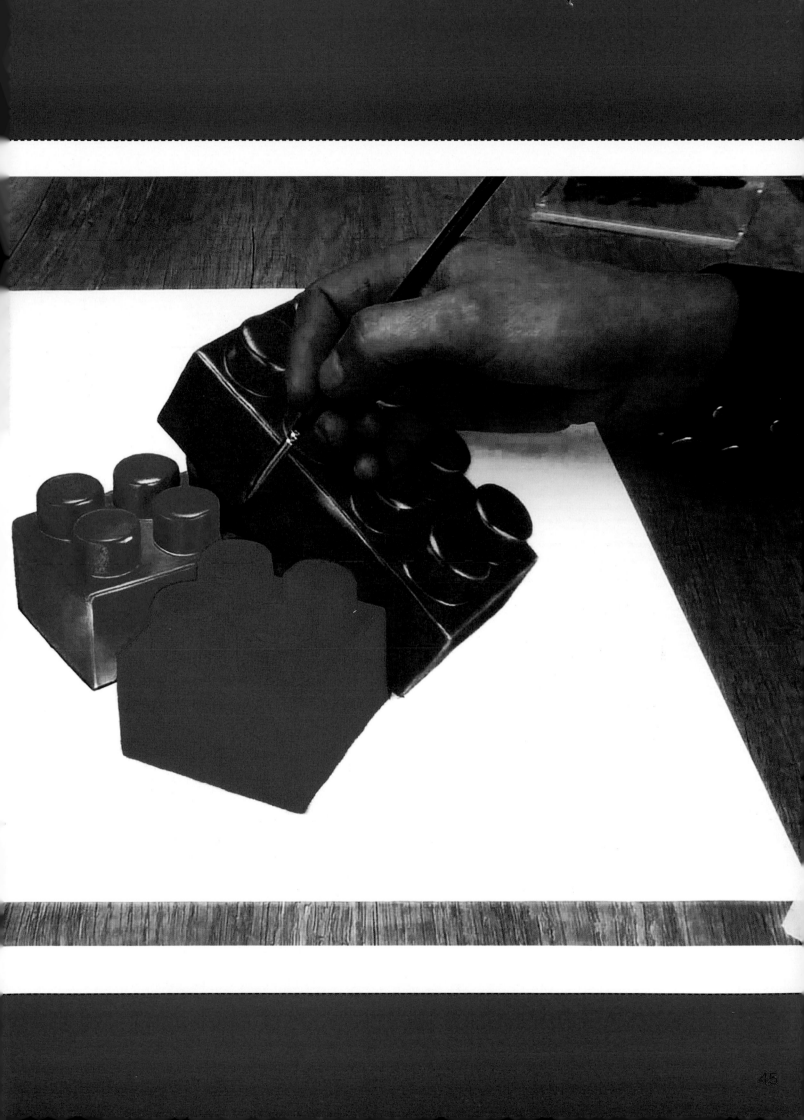

4

THE DROP SHADOW

Now it's time to paint a drop shadow. This will ground the image, making it look even more real. The drop shadow must be painted lightly with smooth, even transitions.

Use a large, clean brush for this step. The larger the brush, the more evenly you can apply the paint. Coat the brush with as much black paint as you can. Rub each side of the paintbrush on a piece of rough paper until the brush transfers just a slight amount of paint to the paper. The brush should now be mostly dry.

Once again, paint the darkest areas first, and then move to the slightly lighter areas. As you work, the brush will gradually contain less paint. Now paint the lighter sections. This will create a smooth transition between dark and light.

A GOOD DROP SHADOW IS AN IMPORTANT PART OF CREATING A SUCCESSFUL 3D EFFECT.

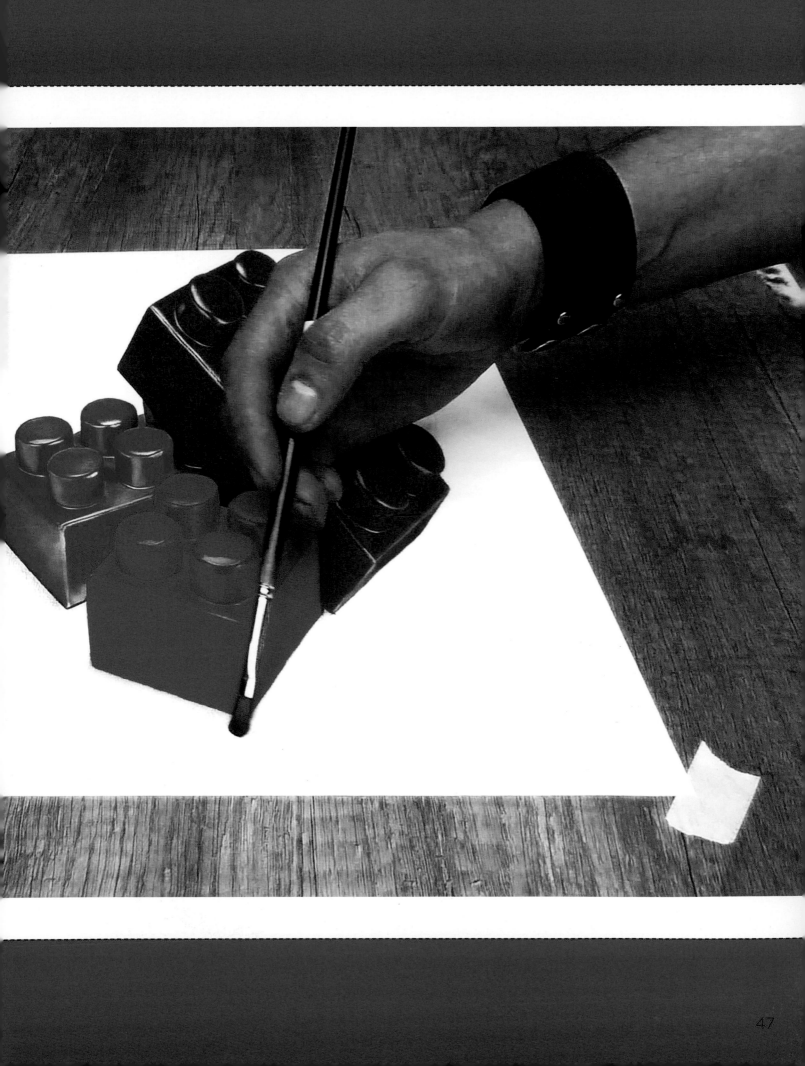

5 | SHINE

Adding shine to the Legos gives them volume and makes them look natural. Using a clean brush, dab white paint on the shiny parts of the Legos. Dab the paint rather than smearing it; otherwise, the white will mix with the other paint colors.

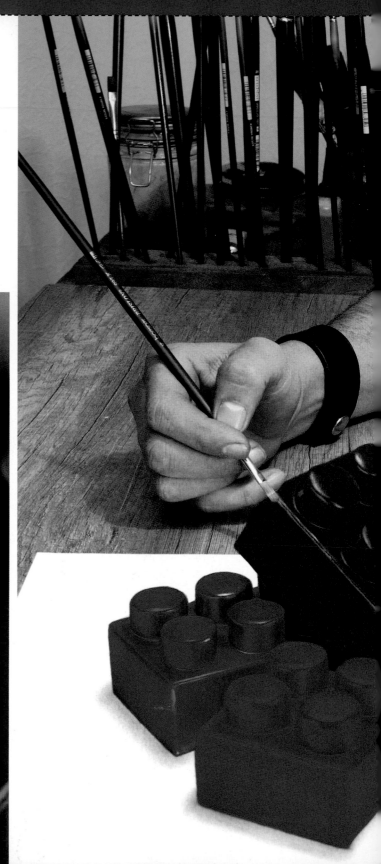

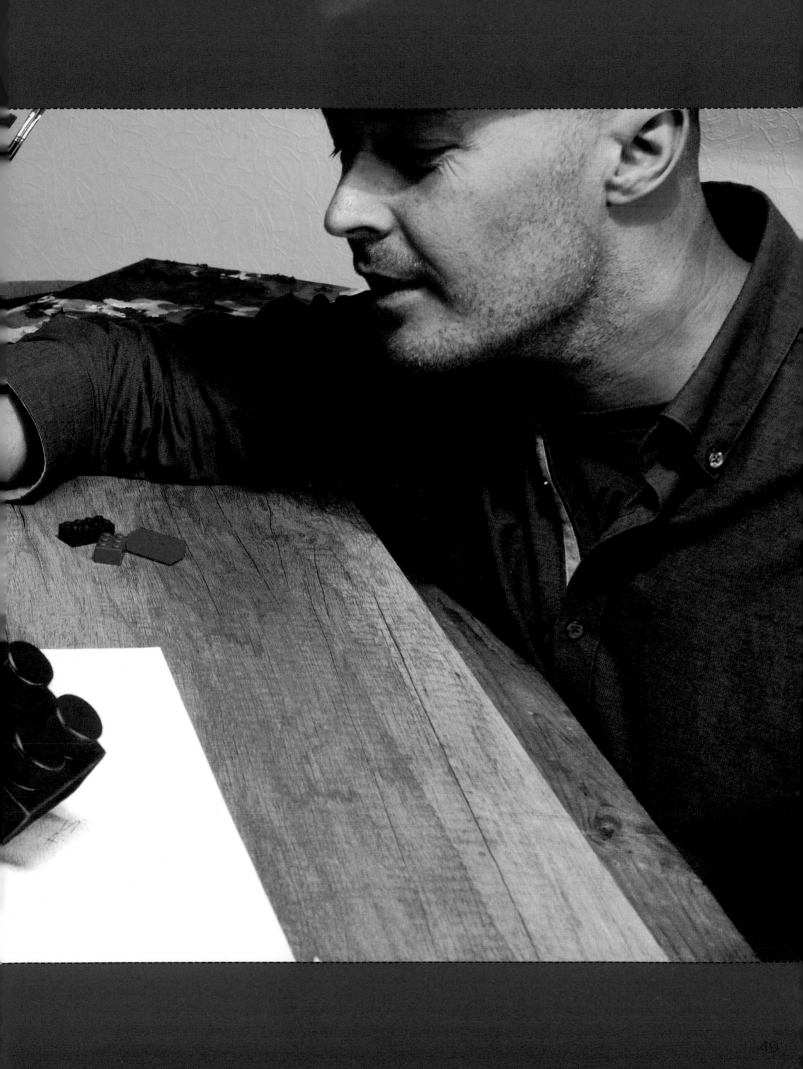

6 BREAKING THE LIMIT

Your Legos should now look three-dimensional. Making them actually protrude off the paper will reinforce the illusion. Use scissors to cut around the top of the red Lego and give the impression that the blocks tower over the sheet of paper.

Now rest your chin on a stack of books or your drawing table as you did to sketch the Legos, and look at the painting again. Do the Legos still look a little unrealistic? Perhaps you have forgotten to include something? Could anything still be improved? If the painting is done right, the three-dimensional effect will be very apparent.

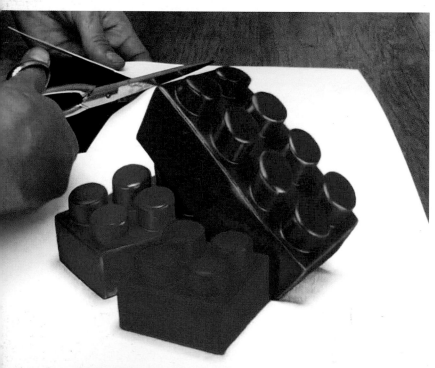

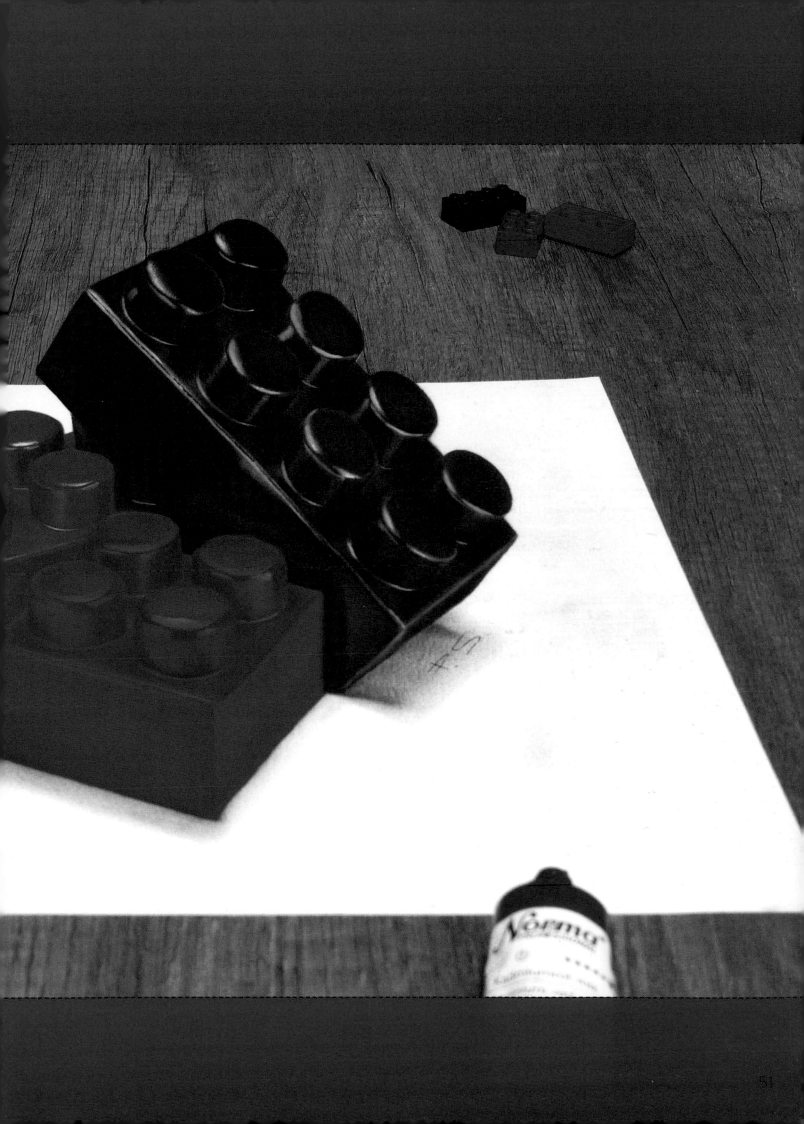

PLANE

Next you'll paint a floating object in the form of an airplane "flying" over a sheet of paper. This project will really test your technical skills. You'll want to make sure the plane looks like it's above the sheet of paper and not just painted on it with a distorted shadow. But let's take this one step at a time!

MATERIALS

- Watercolor paper
- Pencil
- Blue and black oil paints
- Small and large paintbrushes
- Black, blue and gold (or yellow) fine, felt-tip pens
- Rag for painting

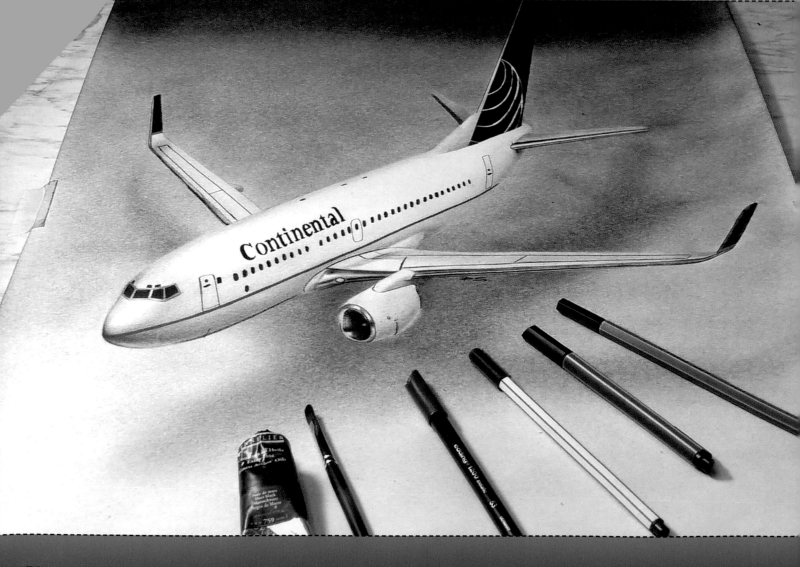

1 SKETCHING

You'll need to draw a top-down diagonal view of the plane to match your viewing angle. Getting the viewing angle just right will create a convincing illusion. There are a couple of options to accomplish this. You can find a picture on the Internet that shows a plane from exactly the right angle and use it to create a distorted anamorphic copy of the image, or you can copy the distorted image shown here.

DETAILS

Your goal here is to darken the background and leave the airplane white, creating an effect that looks as if the plane is flying above the surface of the paper.

Add a bit of black paint to a small brush, and using the drybrushing technique (see page 16), paint around the airplane onto the background. This creates an outline of the plane.

Then use a ruler and black, gold, and blue pens to add details to the plane, such as the lines on the wings, the windows, and the lettering.

3 SHADOWS

Now you can start to shade the plane. Add a small amount of black paint to a large brush, and use the drybrushing technique to apply the shadow on the bottom of the plane. As you rub paint from the brush onto the paper, the paint will become lighter and more even. Don't forget the details, like the blue accents on the wings!

CREATING A GENTLE TRANSITION BETWEEN LIGHT AND DARK SHADOWS MAKES THE PLANE LOOK THREE-DIMENSIONAL AND ROUNDED, NOT FLAT.

PLANE

4 BACKGROUND

The background should look like it's underneath the plane, as though it's on a completely different level. To accomplish this, the background needs to be darker than the plane, with the plane casting a drop shadow.

You'll first want to darken the part of the paper that's farthest from the nose of the plane. Dividing the color makes the plane's tail look like it's rising into the air.

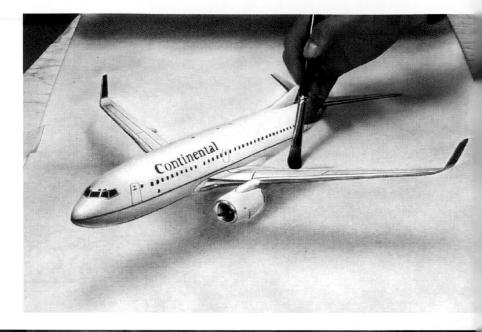

Grab a rag, and scrunch it up. Dip it in black paint, and rub it on rough paper until the paint is well distributed on the cloth and the paint is applied in an even layer. Using circular, sweeping motions, apply paint to the back part of the paper. Use light pressure at first, and gradually increase it. Make sure to apply the paint evenly.

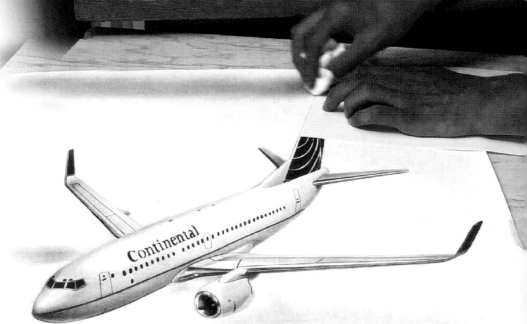

COVER THE PLANE'S TAIL WITH A SHEET OF PAPER SO THAT YOU CAN PASS YOUR PAINT-FILLED RAG RIGHT OVER IT.

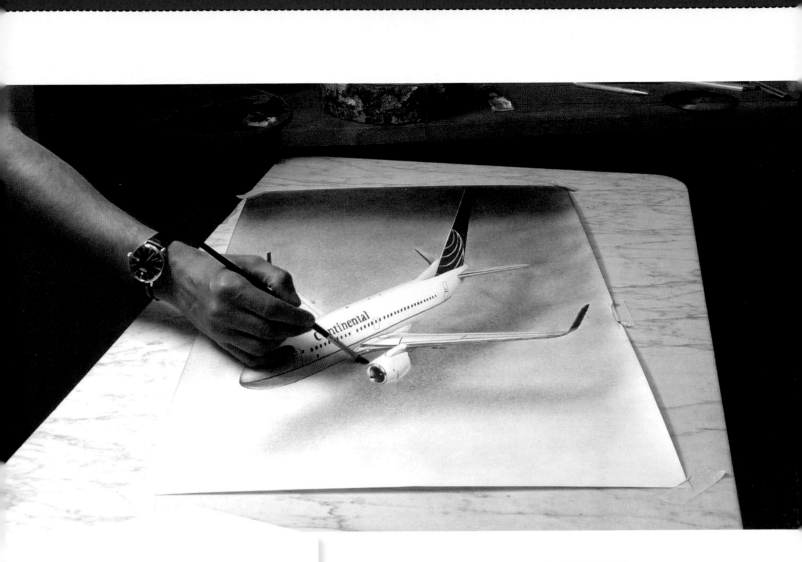

Darken the drop shadow if necessary. It should be darker than the rest of the background. You can use a brush for this step.

PERFECTLY PROPORTIONATE

Take a few steps back, and look at your final result. I like to walk backward about 5 feet and give myself an angle of approximately 45 degrees, so the 3D effect is most visible. I move slowly back and forth, up and down, left and right until the plane looks proportionate, realistic, and not distorted.

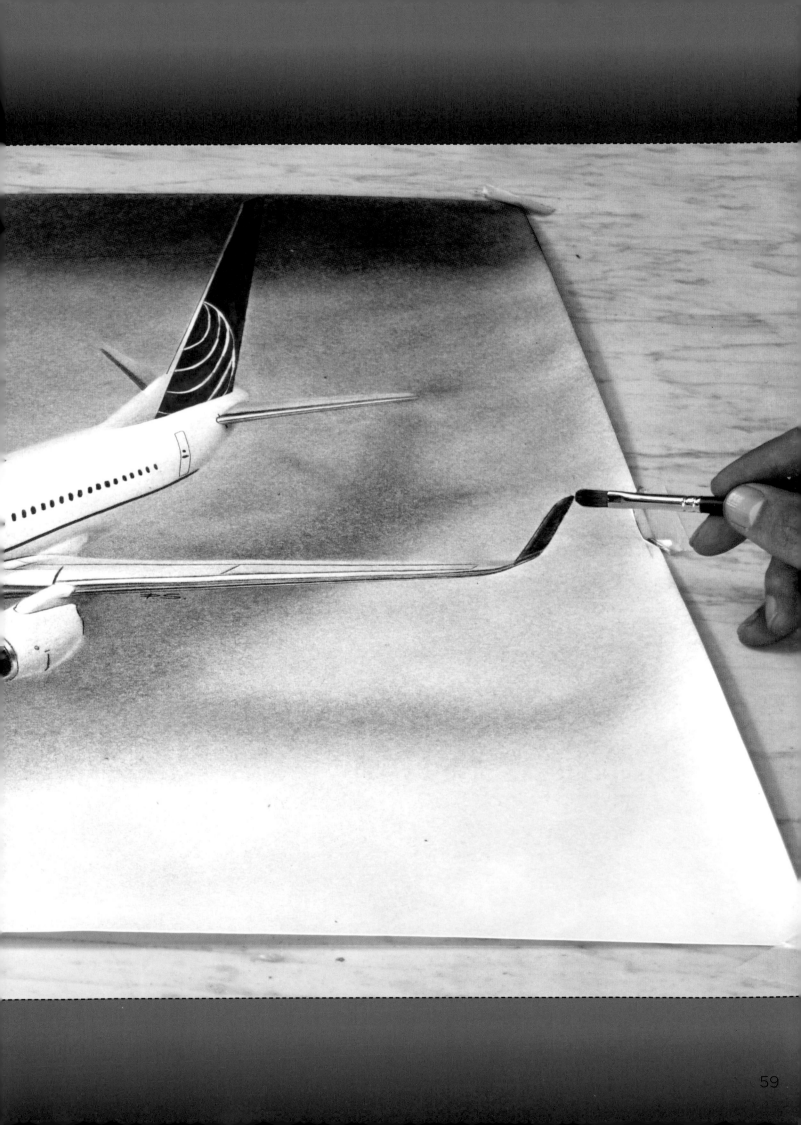

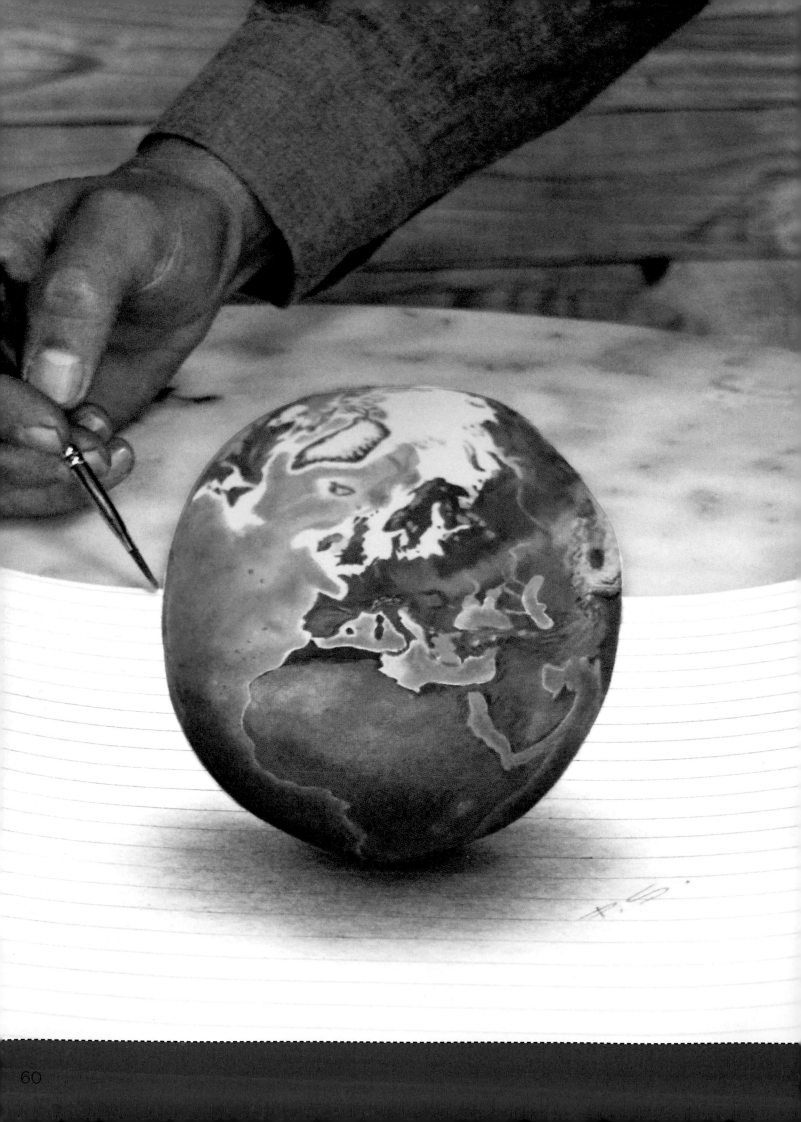

PLANET EARTH

We're all used to looking at images of the Earth, so to get your viewers' eyes to see it three-dimensionally, you have to work very precisely. When drawing freehand, you won't be able to produce a perfect replica of an object, and you don't have to. Your subject should look painted rather than photographed, and it's OK to have a few small imperfections.

Still, the Earth should look as round as possible, and each continent must retain its natural proportions. Choosing the right colors is also important for creating a true-to-life image.

MATERIALS

- Large sheet of drawing or watercolor paper (11 x 17 inches)
- Tape
- Small plate
- Pencil
- Oil paints in white, black, green, blue, yellow, burnt umber, and gold ochre
- Paintbrushes
- Scissors
- Ruler

1 SKETCHING

Use a piece of tape to attach a sheet of paper to your drawing table. Then place your chin on the table or on a book in front of the sheet of paper to stabilize yourself as you draw.

Place a small plate on its side on top of the sheet of paper, and hold it in a standing position. Close one eye, look past the plate's edge, and trace around it, making sure you draw roughly in the center of the sheet of paper. You have now copied a vertical circle onto a horizontal surface. The result is an oval that looks like a perfect circle from your perspective.

Now do a detailed drawing of the Earth's features, such as the continents, inside the circle. Use a map as a reference, and draw the Earth's elements as realistically as you can.

ADDING COLOR

Outline the entire circle with a mixture of cobalt blue and white. Use cobalt green as your base color for most of the land. To make the green look more natural, you can mute it by mixing in a little burnt umber.

For grasslands, use a bright green mixed with gold ochre and white.

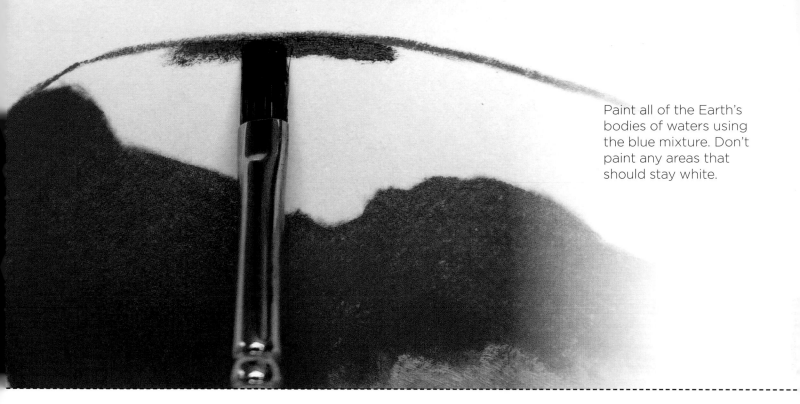

Paint all of the Earth's bodies of waters using the blue mixture. Don't paint any areas that should stay white.

With a clean paintbrush, add white paint to the lightest parts you see on the map. Work from light to dark using the wet-into-wet technique (see page 18). This ensures smooth transitions.

To create a lighter color, add more white paint to your brush. For a darker color, mix the white with your blue background color. Oil paint dries slowly, making this technique possible.

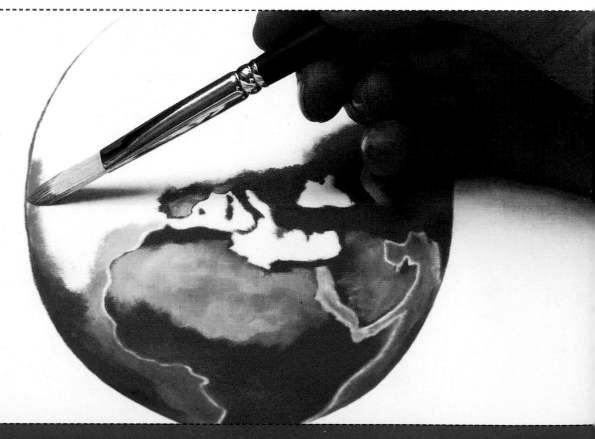

Now grab another clean paintbrush, and add a little black paint to it. Rub the brush on a separate sheet of paper until it's almost dry. The black paint should rub off on the paper only slightly. Now paint dark to light on the darkest areas you see on your map.

Take a step back, and check if the sphere looks even. Touch it up if necessary.

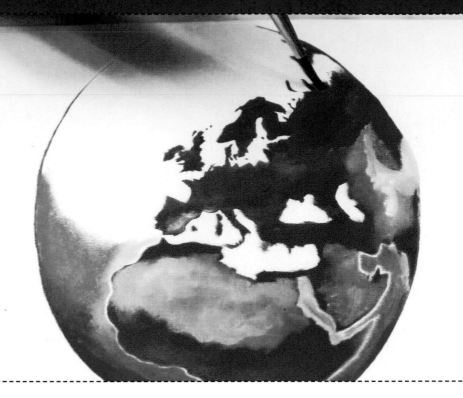

3 SHADING

By now, the painting should be mostly finished. If a sphere were standing on a sheet of paper, it would cast a shadow, so you'll need to paint a soft drop shadow beneath the sphere.

Use black paint and a large watercolor brush. Add a little paint to the brush, and rub the brush on a rough sheet of paper to remove most of the paint. Now paint directly under the sphere, brushing from dark to light and increasing pressure, to create the shadow.

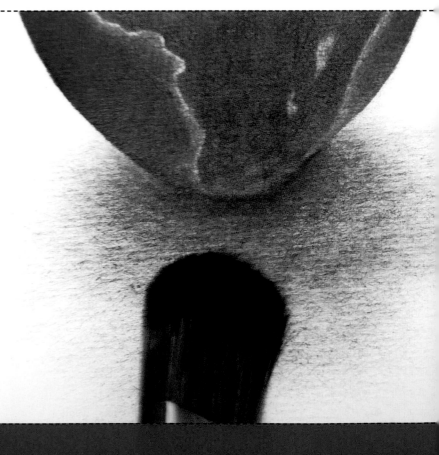

CUTS + LINES

This trick will make your eyes believe that your painting is actually standing on the sheet of paper. Draw a straight line across the top of the painting, and cut around the top part of the Earth. Thus it looks like the painting goes beyond the paper.

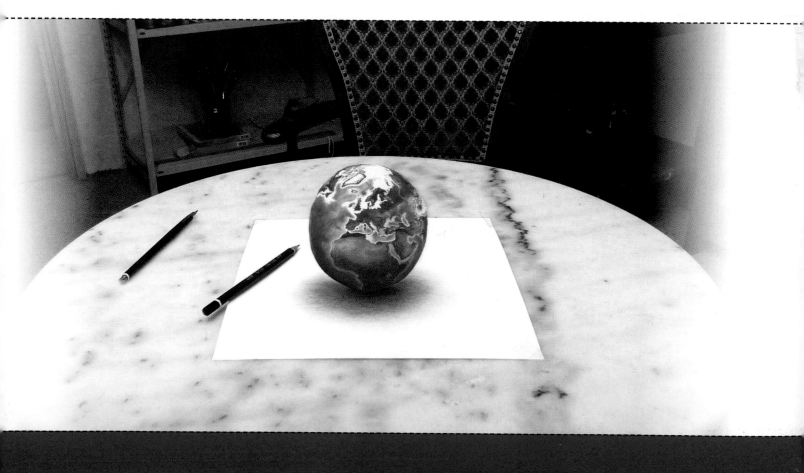

TESTING OUT
THE 3D EFFECT

Once your painting is finished, place your head on the table or on a book, just like you did while sketching. From this angle, your painting should look like a three-dimensional sphere. The effect may be more visible if you close one eye.

What's the first thing you notice? Does the shading look realistic? How about the drop shadow? Is there anything that indicates that the object is actually flat? Make any necessary adjustments. If you've done everything correctly, the planet should look touchable but still real.

WITHOUT A POINT OF REFERENCE, IT'S DIFFICULT FOR THE EYES TO ORIENT THEMSELVES. ADDING HORIZONTAL LINES ON EITHER SIDE OF THE PAINTING PROVIDES THE EYES WITH A POINT OF REFERENCE AND MAKES THE EARTH LOOK LIKE IT'S PROJECTING INTO THE AIR, GIVING IT A MORE THREE-DIMENSIONAL EFFECT.

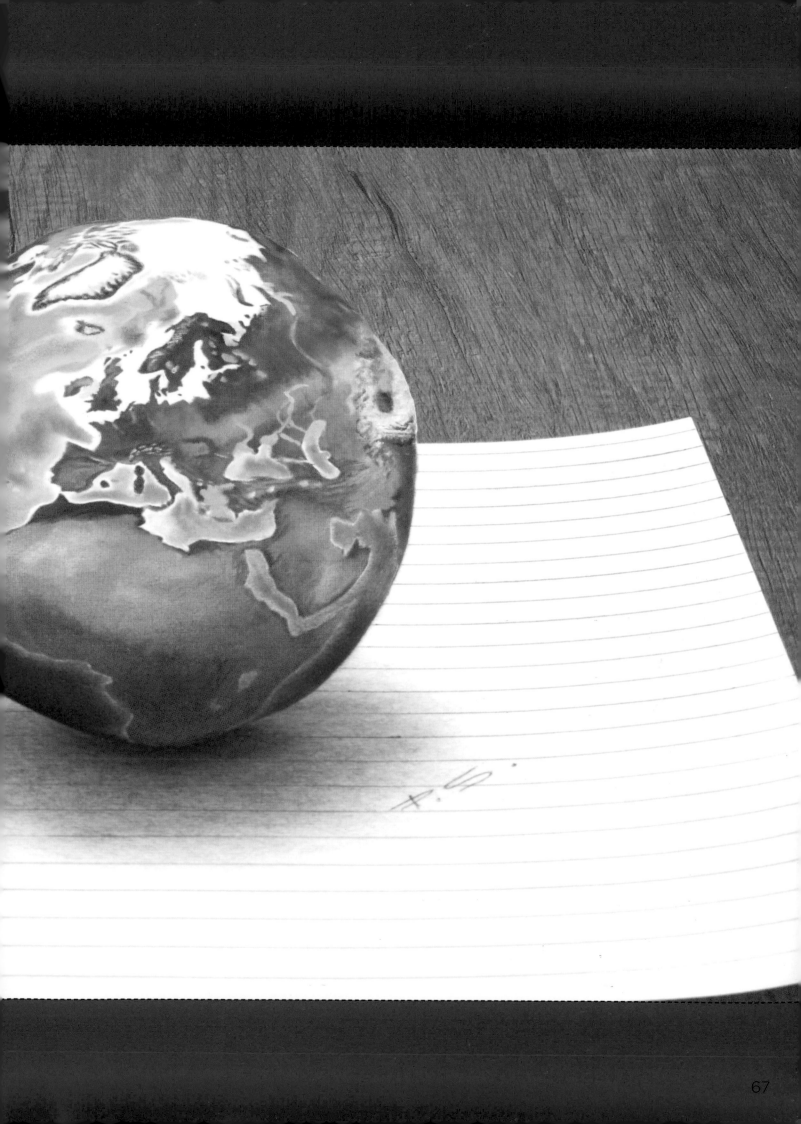

GLASS

In this project, you will create something especially challenging: a three-dimensional glass. It can be difficult to paint glass, and you'll need to pay attention to a few details in order to make it appear transparent. Creating a skillful interplay between shadow and spots of light creates both shape and lightness in a transparent object. The water must also look clear and dynamic, so keep these tips in mind as you begin drawing.

MATERIALS

- Sheet of paper
- Pencil
- Black oil paint
- Cat's tongue brush in size 4
- Ruler
- Large paintbrushes, such as a No. 6 or 18 and a No. 12
- Scissors or utility knife

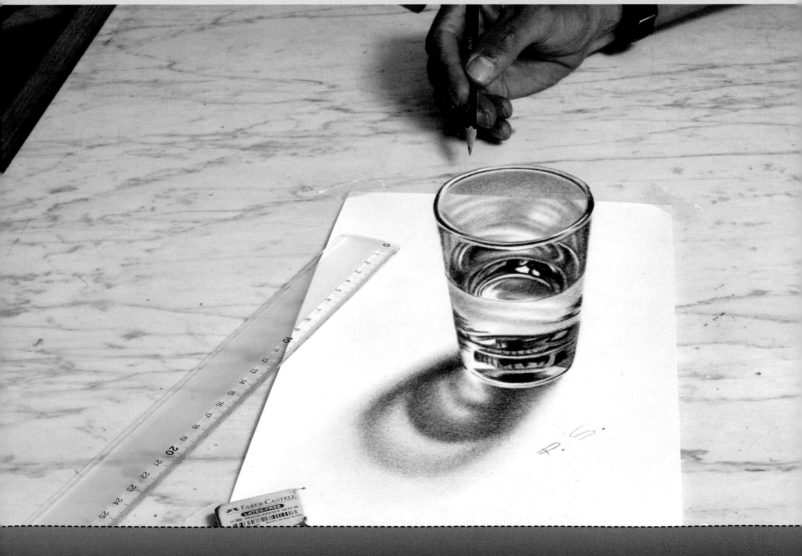

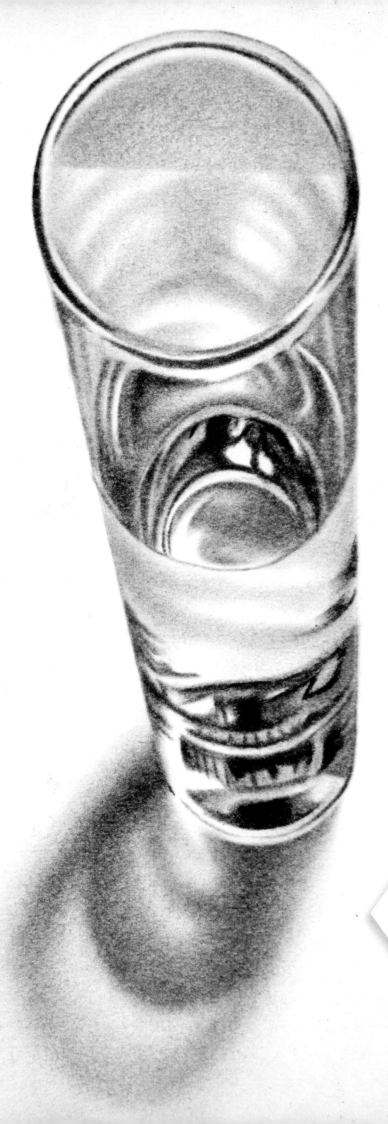

1 SKETCHING

You'll need to create an anamorphic image (see page 19) so that the glass of water really looks like it's standing. Even when viewed from the side, the glass should appear proportionate and upright on a table or sheet of paper.

This requires painting an elongated, distorted perspective of the glass by stretching the side facing away from you. The glass must look realistic in size, or it will be immediately noticeable that it's too small or too large to be real.

You have two options for sketching the glass:

Option 1: Place an actual glass on your drawing table, and copy it onto a sheet of paper using the keyhole sketching method (see page 15).

Option 2: An easier option is to copy the image on the left.

PAINTING IN THE DARK

Take another look at the picture on page 69. With your cat's tongue brush, paint all of the areas that look almost or entirely black. Then use sweeping motions and less black paint on the brush to paint the dark gray areas, starting with the edges. The pencil strokes should no longer be visible.

USE BLACK OIL PAINT WITH HIGH COVERING POWER.

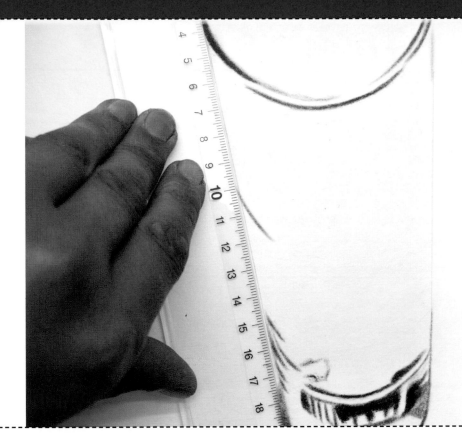

For the sides of the glass, which should be gray, you can use a pencil and a ruler to draw straight, light lines.

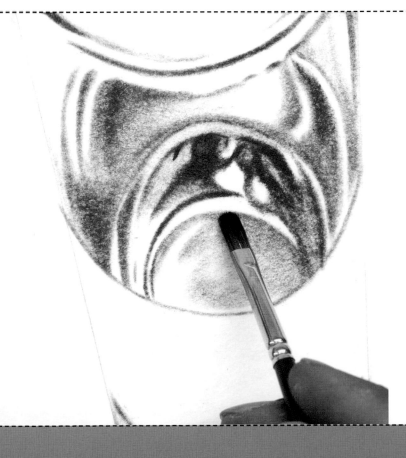

Using a larger brush (No. 6 or 8) and the drybrushing technique (page 18), paint the big gray areas, such as the water in the glass. To achieve different degrees of light and dark gray, apply more or less paint to your brush before smearing the majority of the paint onto a sheet of rough paper. Use a larger No. 12 brush that's practically dry to apply paint to even larger areas of gray, such as the reflection within the glass.

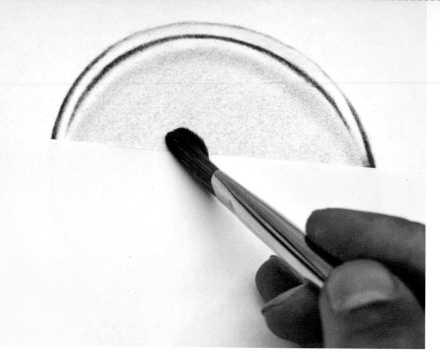

Place a sheet of paper over the top of the drawing, and use sweeping motions to shade the top portion of the glass. Paint over the sheet of paper almost as though it isn't there. (I'll explain why later.)

3 THE DROP SHADOW

A real glass of water casts a drop shadow. The drop shadow plays an important role in a three-dimensional picture. Without a convincing shadow, the picture won't look real.

To create a soft, realistic-looking shadow, you must work very precisely. Follow the same basic techniques as in the previous step. Apply a small amount of paint to your cat's tongue brush, and rub the brush on a sheet of rough paper until the paint smears only slightly. Then place your brush near the bottom of the glass, where the shadow should look darkest, and shade from dark to light using sweeping motions.

In my art studio, the light shines on my drawing table from right to left, so the glass's shadow needs to fall on the left side.

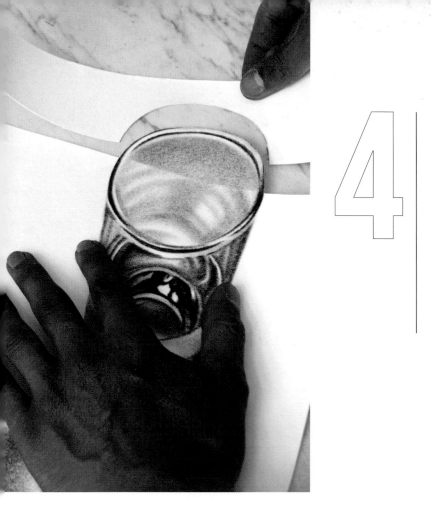

4 | OUT OF BOUNDS

When you look at your painting from the side, the glass of water should look three-dimensional and as though it's standing on the sheet of paper. You can enhance this effect by cutting out the glass.

Place a ruler along the line separating the darker section of the glass from the lighter one, where you covered part of your drawing with a sheet of paper. With scissors or a utility knife, cut along this line, making sure to cut around the glass, not through it.

5 | CREATING THE PERFECT ILLUSION

Now look at your picture from the side, and notice that the glass of water extends beyond the sheet of paper. Your eyes can no longer explain why the image goes past the edge of the paper, so they automatically draw the conclusion that the glass of water is not part of the paper and, in fact, stands on top of it. Now you've achieved your goal and have succeeded in creating the perfect illusion!

Painting a living creature, such as a ladybug, is challenging for any artist. You want to create the impression that it could fly away at any moment, so the subject needs to be drawn and painted with natural-looking proportions and lifelike colors. As you paint, concentrate on the lines, blending your paints, and thinking about the subject as a living thing. This will infuse your image with energy.

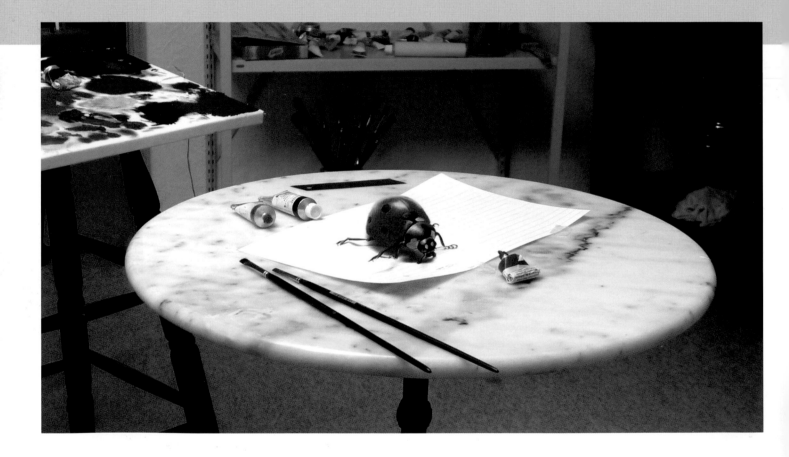

MATERIALS

- Tabloid-sized sheet of white paper (11 x 17 inches)
- Pencil
- Ruler

- Oil paints in black, red, yellow ochre, and white
- 3 brushes: a flat synthetic one and 2 cat's tongue brushes in sizes 4 and 12
- Ballpoint pen
- Scissors or utility knife

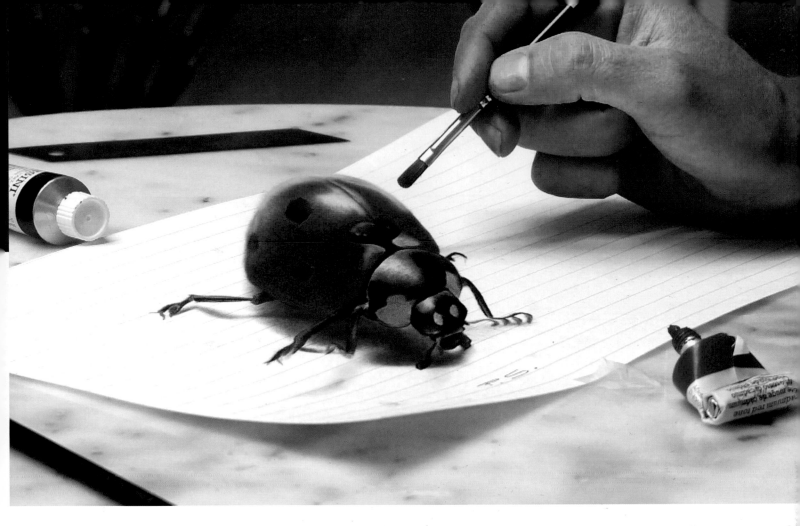

1 OUTLINING

You will want to paint the ladybug from the side and with the right proportions. As with the cube on page 18, this means you have two options:

Option 1: Study the painting above, and copy it using a pencil and the keyhole sketching method described on page 15.

Option 2: Copy this distorted painting with a pencil. To get the proportions right, you can place a blank sheet of white paper on top of my painting, and trace over it before adding color.

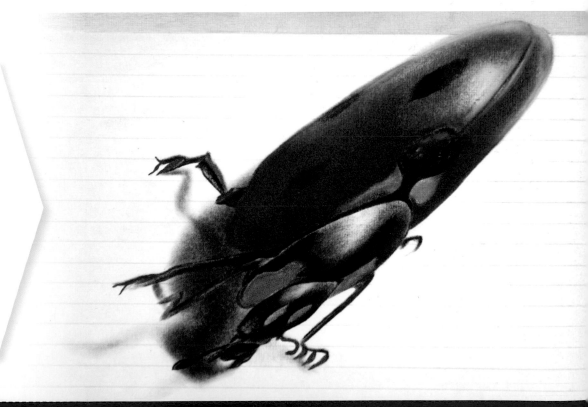

ADDING COLOR

Use a small cat's tongue brush and black oil paint to outline the black parts of the ladybug (its head, legs, and spots). Then do the same with your red paint on the red parts of the ladybug.

Look at the painting on page 75, and notice which parts of the ladybug look yellow. Paint these with yellow ochre.

After outlining each area, fill it in using a larger brush. This keeps the paint colors from mixing.

Soft transitions and blended colors will make the ladybug look lifelike.

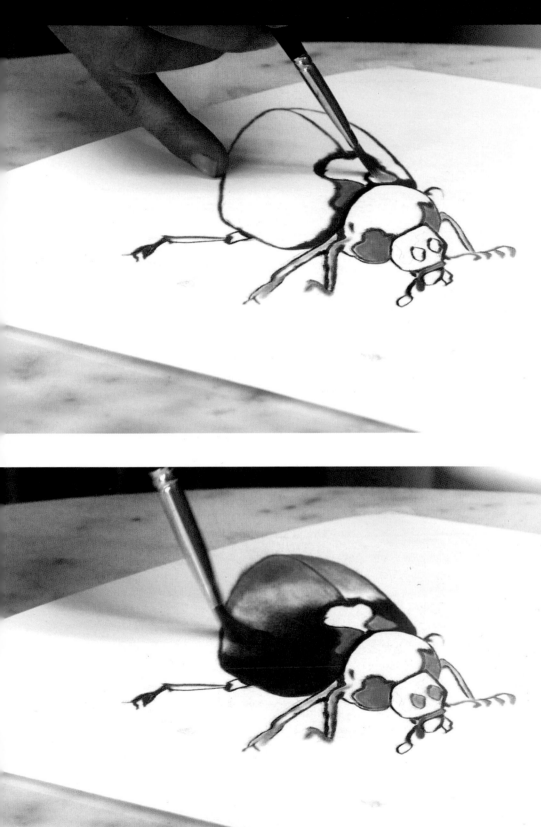

TO PREVENT YOUR HAND FROM SHAKING AS YOU PAINT DETAILS, PLACE THE TIP OF THE NAIL FROM YOUR LITTLE FINGER ON THE SHEET OF PAPER. IF YOU REST JUST YOUR NAIL, LITTLE CONTACT IS MADE WITH THE PAPER AND NO OILY RESIDUE WILL BE LEFT BEHIND, BUT THE HAND IS STILL SUPPORTED.

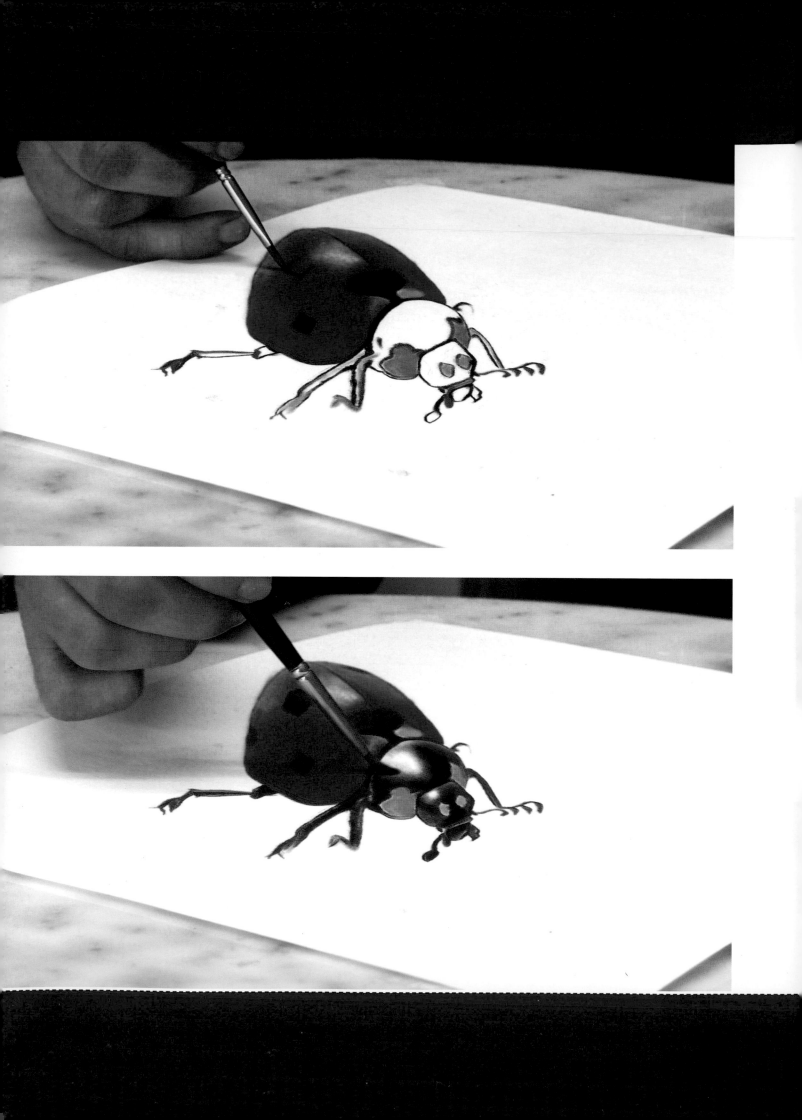

CREATING A SHADOW

By now, the ladybug looks real and features lifelike colors, but it doesn't connect with the background. It almost looks like it hangs on the page, so it needs a soft, realistic shadow like the one that a real ladybug would cast on a sheet of paper.

Using the drybrushing technique described on page 16 as well as some black oil paint and a large (size 12) brush, shade the area under the ladybug using sweeping motions. Move from dark to light, and in more detailed areas, such as under the legs and feet, paint with a smaller brush.

A real ladybug would reflect light on a sheet of paper as well, so add a little bit of red paint to the edges of the shadow. Also accentuate shiny areas with white paint.

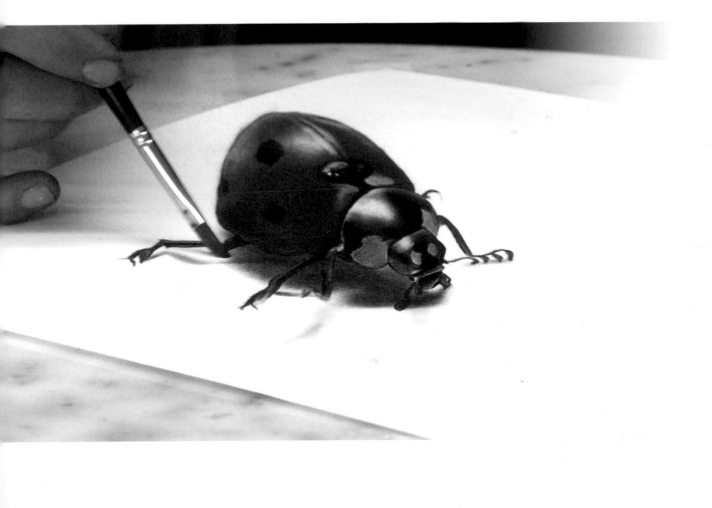

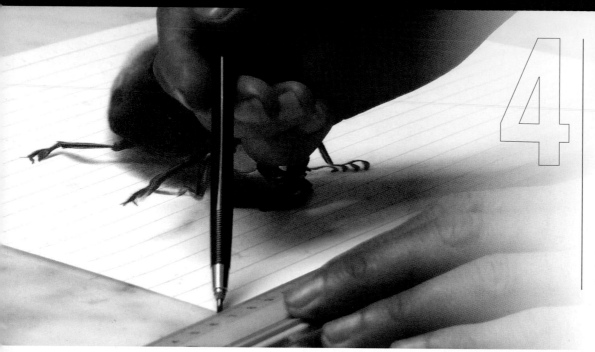

FOOLING THE BRAIN

4

The realistic-looking shadow already makes the ladybug look real, but you can enhance the 3D effect by adding lines to the sheet of paper.

The lines act to orient your eyes. Use a pen and a ruler to add lines across the sheet without covering the ladybug.

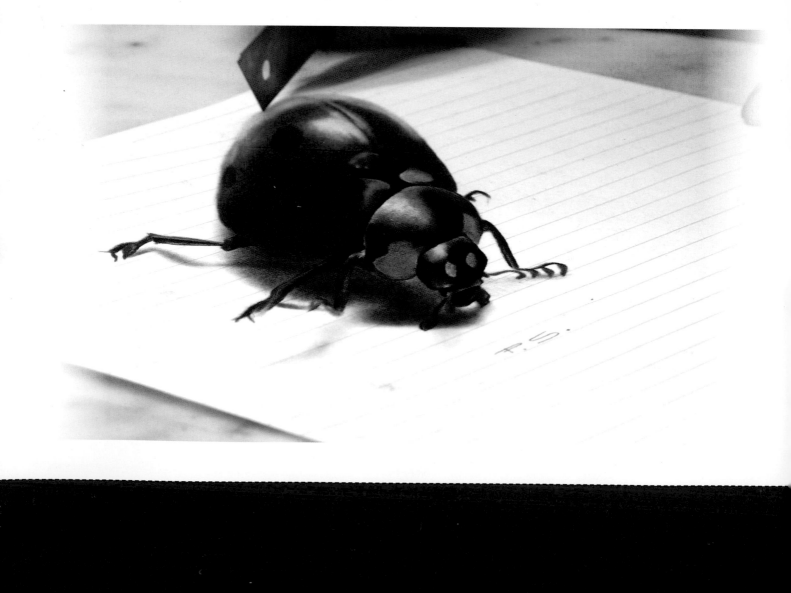

STANDING OUT

This last trick will really outsmart the viewer's brain and make the ladybug appear to stand on top of the sheet of paper. Using a pair of scissors or a utility knife, cut off the top of the page, cutting around the end of the ladybug. This changes the size of the paper, allowing the ladybug to leave the boundaries of the page.

Step back a few feet, and study the painting from about a 20-degree angle. You now have a real, three-dimensional optical illusion sitting in front of you!

PROJECT NINE

CAR

3D pictures can be painted horizontally as well as vertically. In a horizontal painting, the three-dimensional effect is visible from the side. This project will teach you how to paint a beautiful, eye-catching classic car as seen from the side and front.

MATERIALS

- Tabloid-sized sheet of drawing paper (11 x 17 inches)
- Pencil
- Oil paints: cobalt blue, cobalt green, cadmium red, yellow, and titanium white
- Paintbrushes: flat and 2 cat's tongue in sizes 4 and 12
- Multi-purpose oil
- Ruler
- Scissors

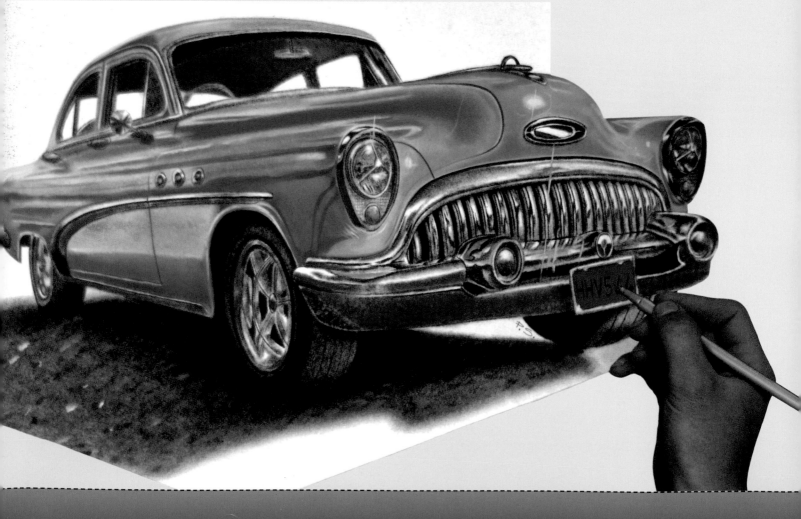

1 DRAWING

To draw a realistic-looking three-dimensional object, you need to distort its width, and then stretch its perspective in the back. Thus, if you view the picture from the side, the subject will look proportionate rather than too flat, and it will look like it's positioned in front of you at a 90-degree angle.

Painting a distorted anamorphic image is tricky, so I recommend using the picture above as a reference. You can trace or draw it freehand.

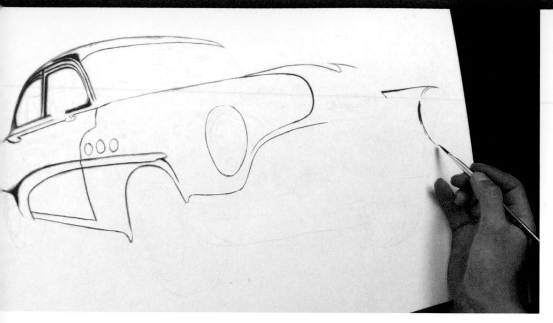

CREATING A BASE COLOR

As you can see in the picture on page 83, the body of this car features many different tones. First you'll want to paint its base color, which is green with a hint of turquoise. You can create this color yourself by mixing cobalt green paint with a little bit of cobalt blue.

Start by outlining the car with a small or flat brush and your base color paint mixture. Then fill in the area you just outlined using the same color. You can use a smaller brush for tighter spots and a large No. 12 brush for bigger areas. Leave certain areas (like the headlights, tires, and windows) unpainted, and add their colors later.

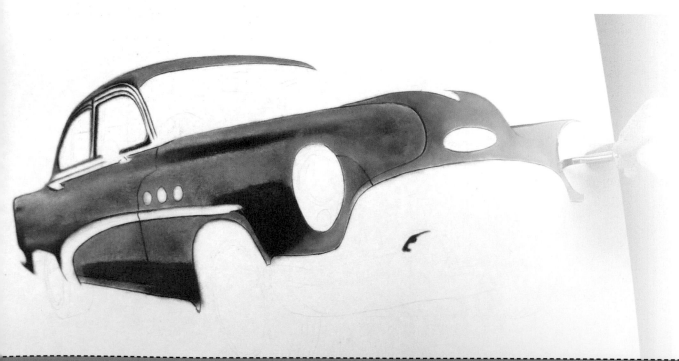

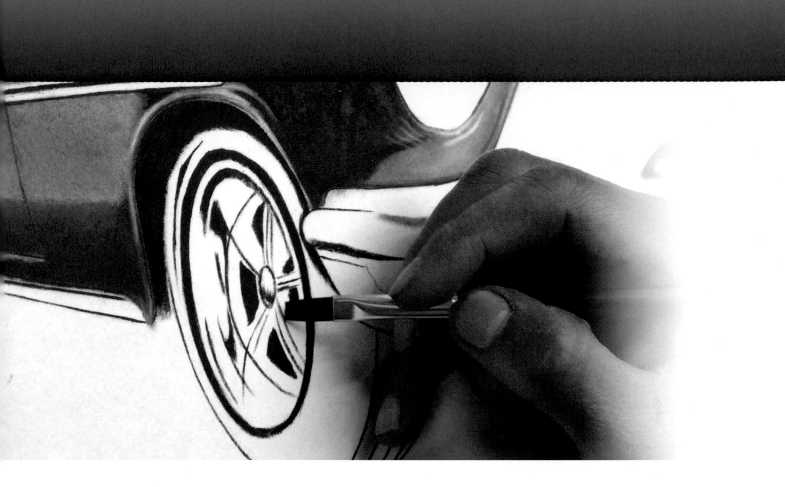

3 ACHIEVING A 3D EFFECT

Now you can start adding tone to the car. Look back at the painting on page 83, and add blue to the darker areas on the car. Add green to the lighter areas and white to any shiny spots. These colors create the dark shadows and light, polished areas that you see on a real car.

START WITH LIGHTER COLORS BEFORE ADDING DARKER, MORE PIGMENTED PAINT. IF YOU MAKE MISTAKES WITH THE LIGHTER COLORS, YOU CAN EASILY COVER THEM WITH A DARKER COLOR. IT'S MUCH MORE DIFFICULT TO COVER DARKER PAINT COLORS.

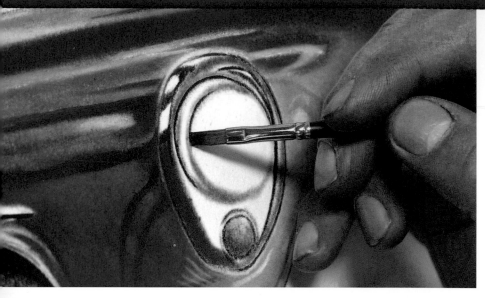

Now add black paint to the black parts of the car and yellow to the shiny areas on the hubcaps. Add reflections using thick white paint. For long, straight surfaces, such as the lines on the side of the car, thin the paint with a little bit of multi-purpose oil, and use a flat brush to paint them on.

4 | ADDING A SHADOW

The car still needs a shadow to imply that it's standing on the ground. You can see that the car stands in direct sunlight, so the drop shadow needs to be quite dark to look realistic.

Use black oil paint to cover the area directly under the car. The shadow should become lighter as it moves outward from under the car. Use the same brush to paint the entire drop shadow, continuing until the brush has no more paint on it.

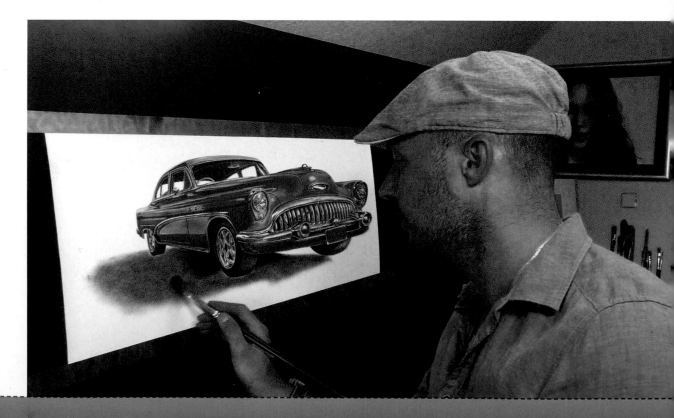

CREATING NEW BOUNDARIES

The car should now look like it sits on the page. You've completed the technical part of creating an anamorphic painting, but you can still add a few more tricks to even better fool your viewers.

With a ruler and a pencil, draw a vertical line on the right side of the drawing and another one under the shadow. Using scissors, cut along those lines to carefully cut around the car and make it pop.

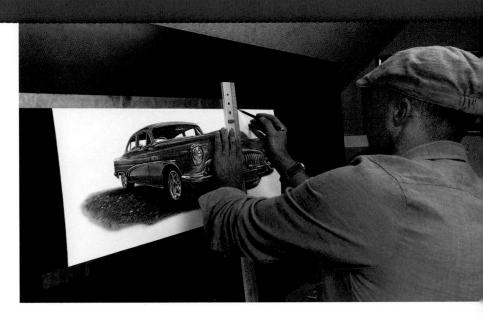

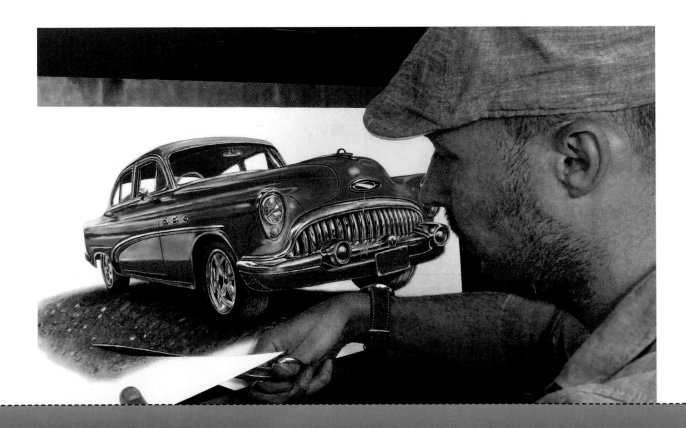

GIVE IT GAS

The car now looks it projects from the picture ... almost as though it's about to drive off the page!

Now take a few steps back, and view the car at an angle of about 45 degrees. Is there anything that you could improve upon? Add any finishing touches, and you're done!

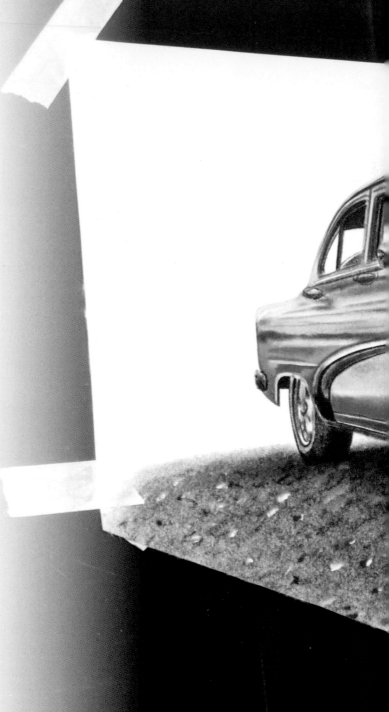

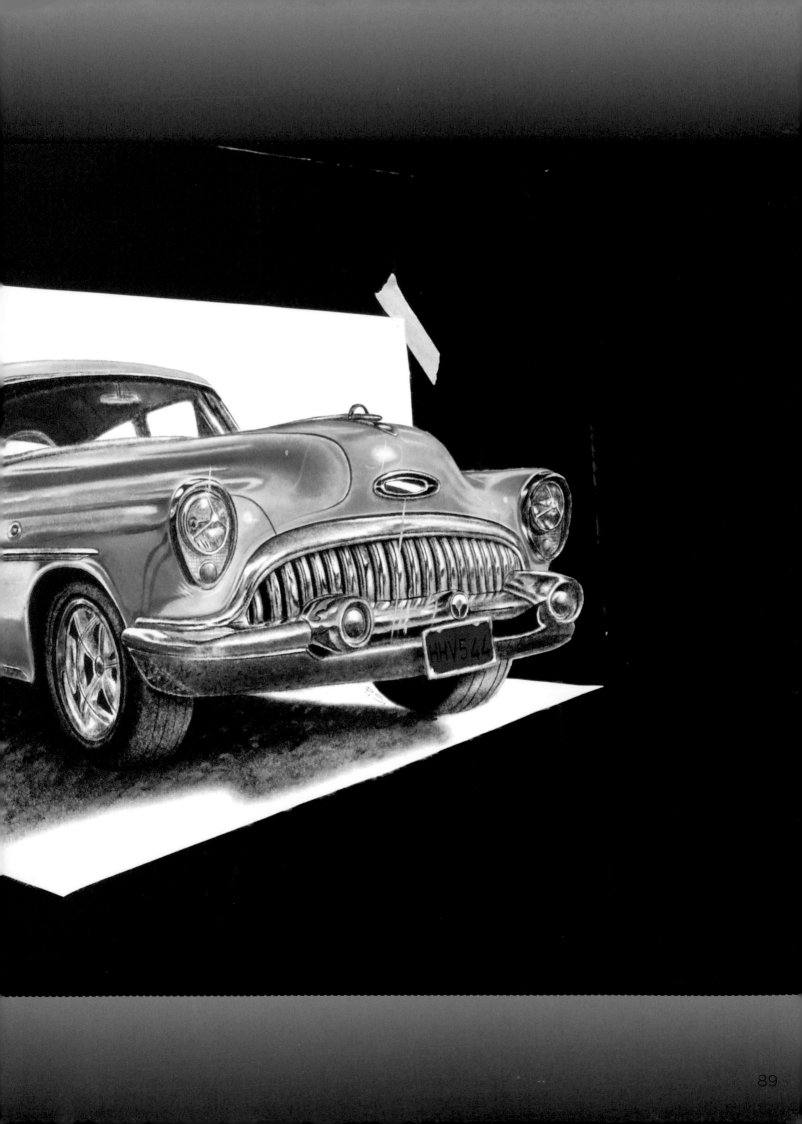

CHICHEN ITZA

Chichen Itza is a city of Mayan ruins on Mexico's Yucatan Peninsula. This artwork replicates El Castillo ("the castle"), also called "the Temple of Kukulcan," which was built between the 9th and 12th centuries as a temple to the Mayan snake deity Kukulcan. Now let's draw this temple in 3D, just as you see it in photographs.

MATERIALS

- Sheet of paper
- Ruler
- Pencil
- Black oil paint
- Large paintbrush
- Scissors

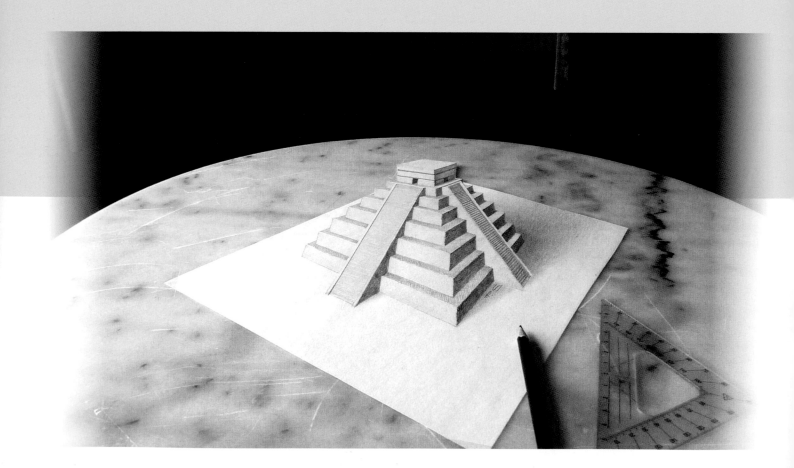

1 | DRAW FIRST

To create a 3D effect, you must distort the perspective so that the pyramid appears proportionate. You can do this by following the keyhole method (see page 15), or by copying my drawing step by step. The pyramid will need to be elongated in order to look proportionate.

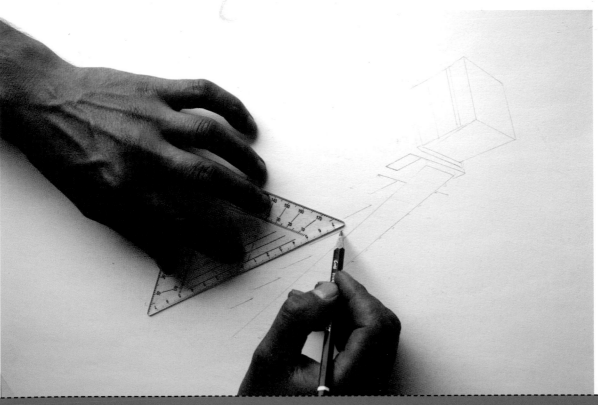

CHICHEN ITZA

If you wish to copy my drawing of Chichen Itza, follow the steps shown here. Your measurements don't need to be the same as mine—just make sure they're consistent. Keep the drawing at a right angle to your body; this will help you draw the pyramid proportionately as well as elongated.

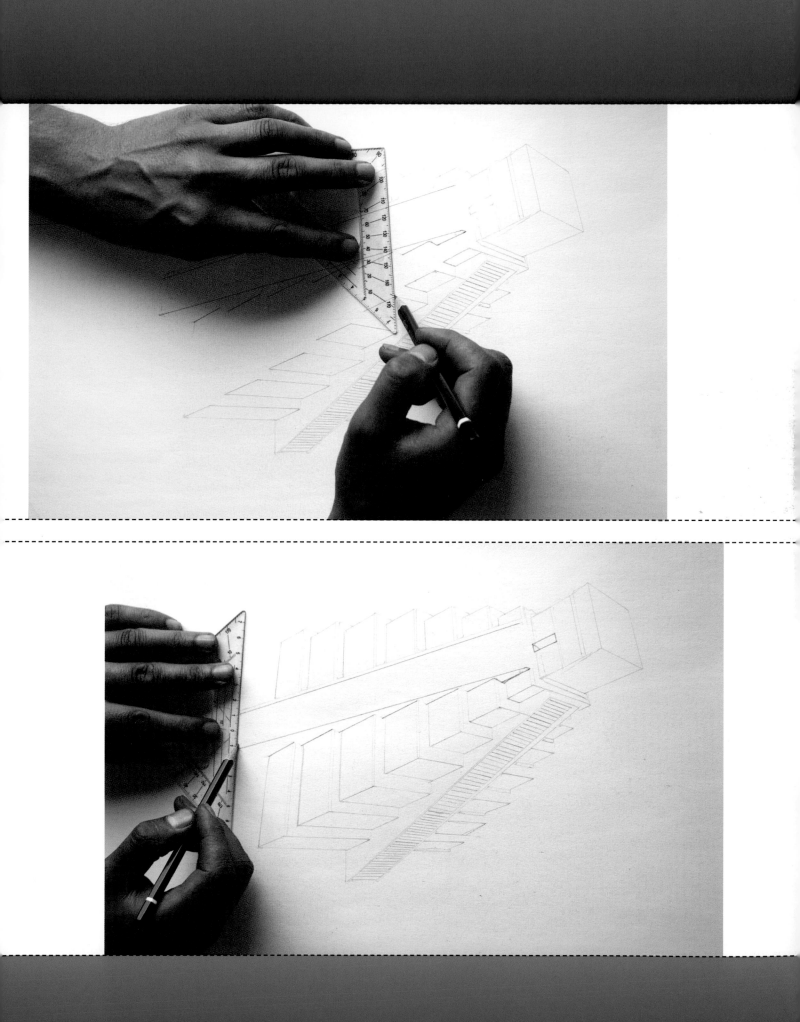

2 | SHADING

Use the pencil to shade parts of the pyramid. To create lighter shading, use light pressure, and move your strokes in a single direction. For slightly darker areas, apply more pressure, shading first in one direction and then in the other. For very dark areas of the pyramid, use crosshatching (page 13) and lots of pressure to fill in the area completely.

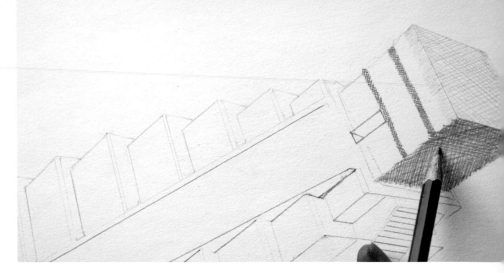

To create a realistic-looking pyramid, the lighting on it must match the lighting in the room where you're drawing. I like to draw in front of a window, which lights one side of my page strongly but unevenly. My pyramid must therefore also be illuminated on one side. I shade the left side of the pyramid quite lightly, and use darker shading on the right side.

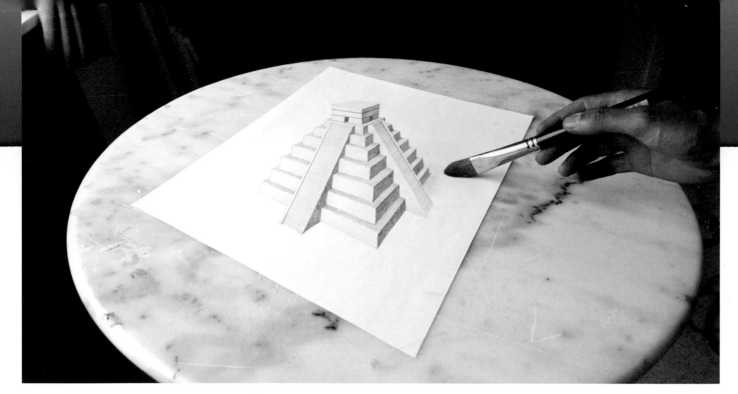

3 | DROP SHADOW

The drawing of the pyramid is complete now, but it still needs a drop shadow to look authentic. This pyramid will cast a dark shadow on its right side. You can use a large brush, black oil paint, and the drybrushing technique (page 16) to create the shadow.

Place the brush, which should only have a bit of paint on it, on the spot where the darkest part of the shadow should appear. Apply the paint as evenly as you can using sweeping motions. Avoid blotchiness. The softer and more even the shadow, the more realistic it will look.

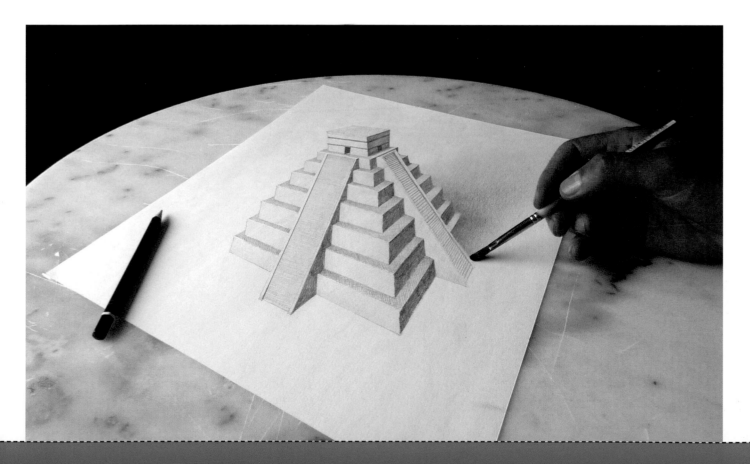

4 | SHADING

This next trick will amaze anyone who sees your artwork and make the pyramid appear not to be a part of the page but, rather, standing on top of it. Cut off the top and left sections of your sheet of paper, making sure to cut around the pyramid. The pyramid now appears to extend past the sheet of paper. Now step back, and take a look at your artwork.

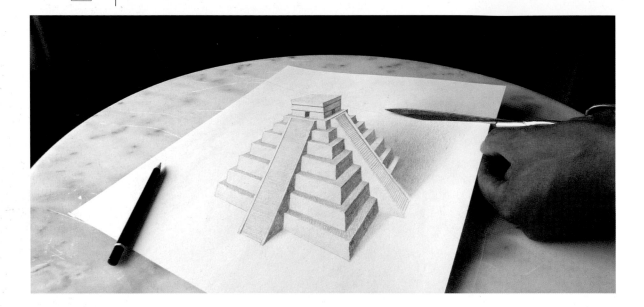

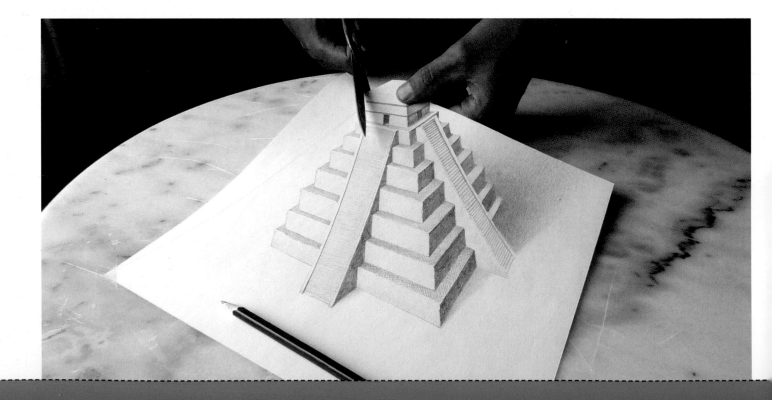

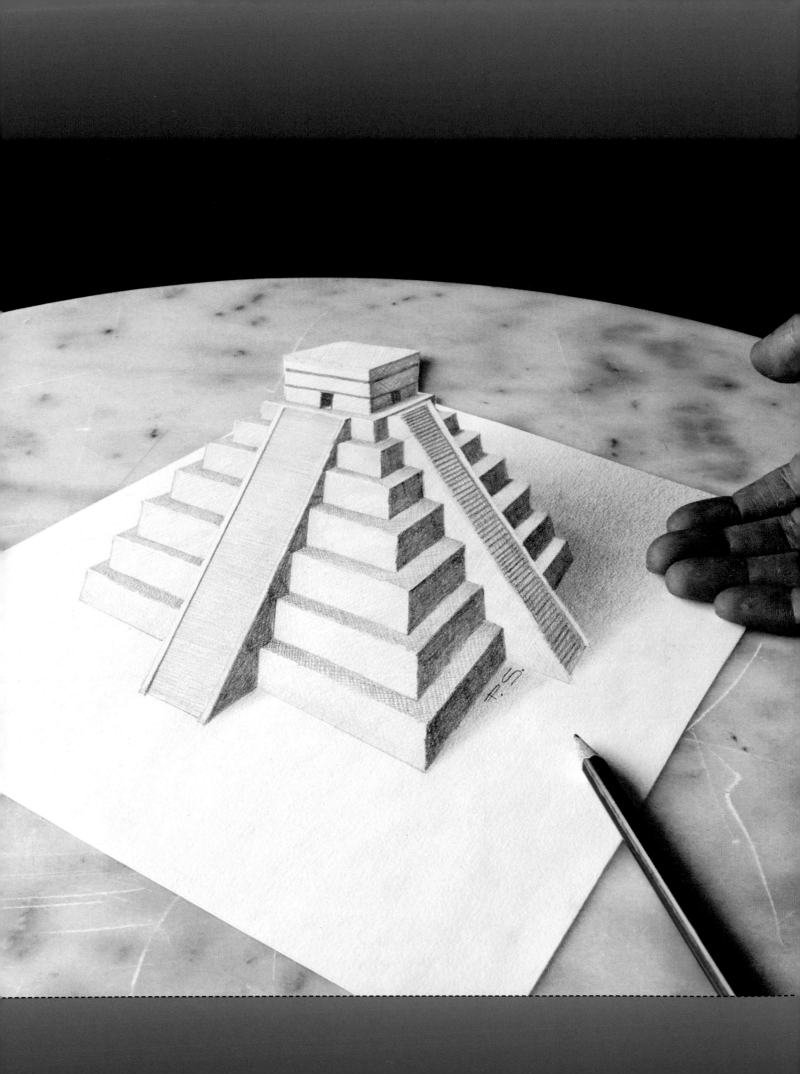

LEANING TOWER OF PISA

The Leaning Tower of Pisa is the bell tower of the cathedral in Pisa, Italy. Completed in 1372, the tower is best known for its unintentional tilt. It currently leans at an angle of about 3.99 degrees. To draw this structure, you don't just want to draw it realistically. You want it to look like it's projecting from the sheet of paper. The way that it leans should also look realistic.

MATERIALS

- Sheet of paper
- Pencil
- Fine felt-tip pen
- Black oil paint
- Small (size 4) and large (size 12 or 16) cat's tongue brushes

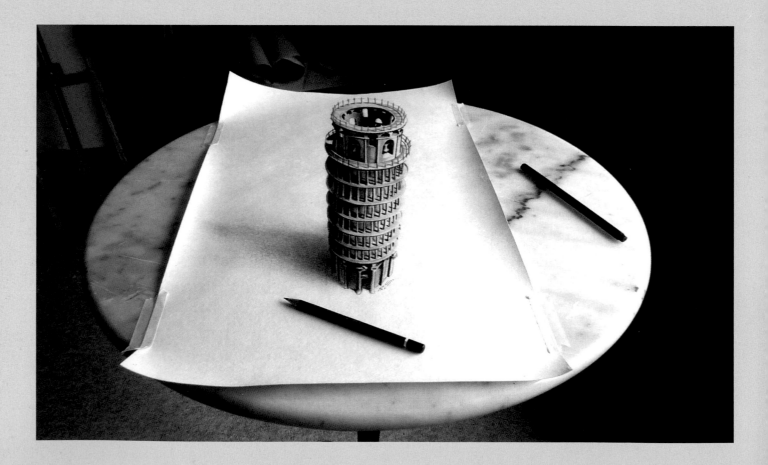

1 SKETCHING & INKING

By the time you've finished this drawing, you want to be able to look at it from the side and see a proportionate Leaning Tower of Pisa. This will require distorting the perspective and drawing an elongated, or anamorphic, image.

To do this, you can copy a photo of the tower onto the left side of a sheet of paper using the keyhole method (page 15). You can also simply copy my drawing step by step by placing a blank sheet of paper over it and holding it up the light.

Now take another look at my drawing or at a photo of the Leaning Tower of Pisa. The areas that look gray can be drawn with an ordinary soft pencil. Draw its black areas with a fine felt-tip pen.

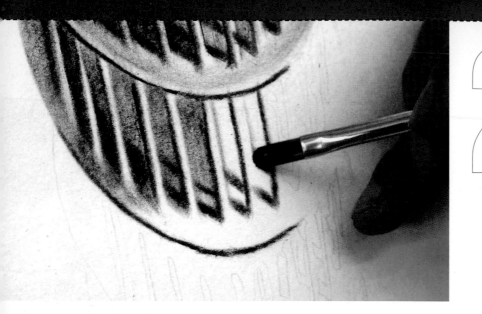

2 ADDING PAINT

After inking in the black areas, go over them again with oil paint. Using a small cat's tongue brush and black paint, paint the tower's shadows from dark to light. Don't smear the paint; use the drybrushing technique (page 16) to rub it on.

WHILE THE BRUSH IS STILL FILLED WITH SOME WET PAINT, GO OVER THE DARKER AREAS ON THE TOWER. AS THE BRUSH GRADUALLY HOLDS LESS AND LESS PAINT, WORK ON THE TOWER'S LIGHTER AREAS.

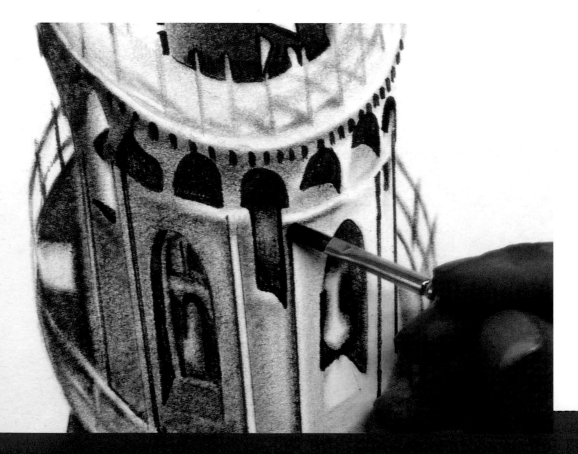

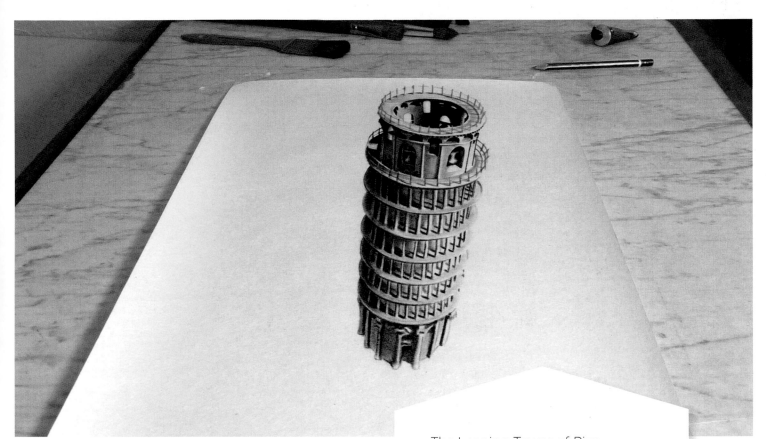

By now, your tower should look something like this when viewed from the side. The sheet of paper frames the tower, which clearly leans but still looks suspended in air. A real tower would cast a drop shadow.

The Leaning Tower of Pisa features lots of small details, such as windows and columns, so the painting process will take a while. It's important to include these details, however, or the optical illusion won't work. Adding light and shadows is also very important. The strong contrast between the two makes the tower look round, convex, and realistic.

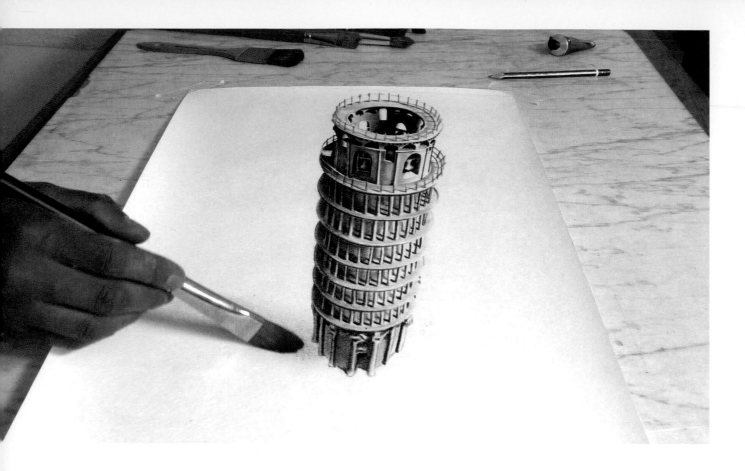

3 CREATING A SHADOW

This painting of the Leaning Tower of Pisa is illuminated from the right, so the shadow must appear on its left side. Soft transitions are essential for creating a realistic-looking shadow.

Use a large, soft, cat's tongue brush, a very small amount of black oil paint, and the drybrushing technique. Place the brush right next to the tower. This is where the shadow should look darkest, so you want to start here while there's more paint on your brush.

Use strong, sweeping movements to paint an even shadow without blotchiness. The less paint you have on the brush, the more evenly you will apply it. Move outward as the paint smears from the brush. The shadow should finish with a soft edge.

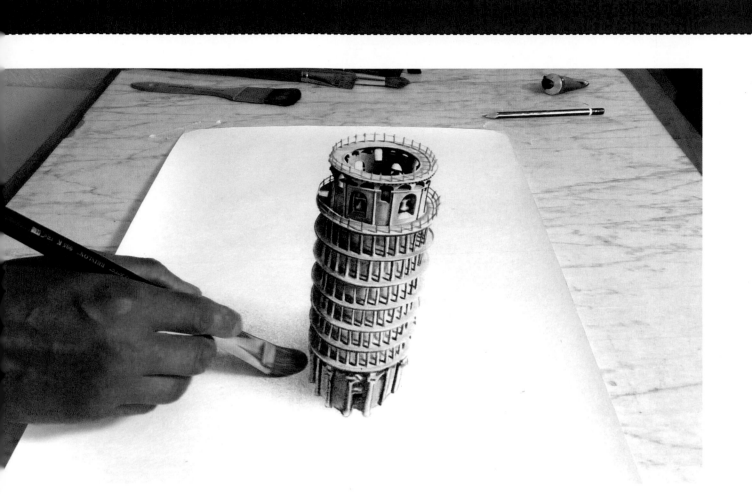

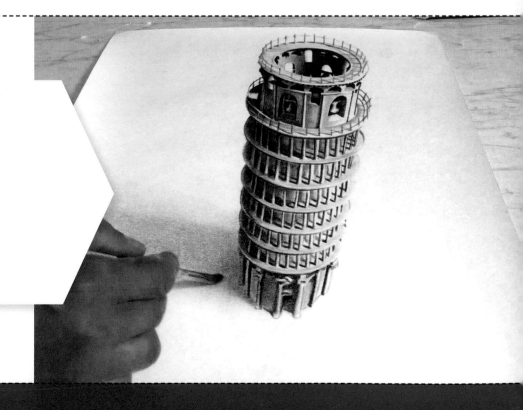

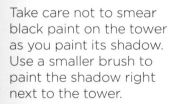

Take care not to smear black paint on the tower as you paint its shadow. Use a smaller brush to paint the shadow right next to the tower.

DISTORTION

When viewed from the right side, your tower should look like this.

The 3D effect will only work from this perspective. If you take a step to the left, the tower doesn't look right.

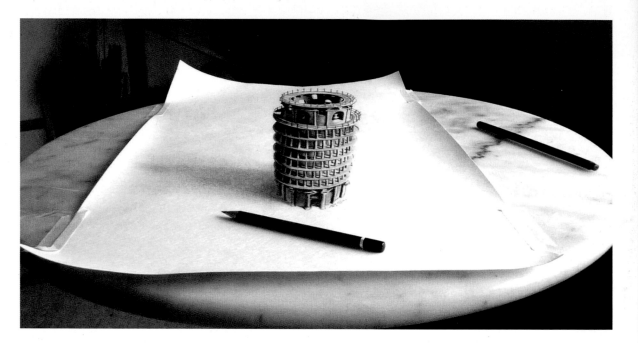

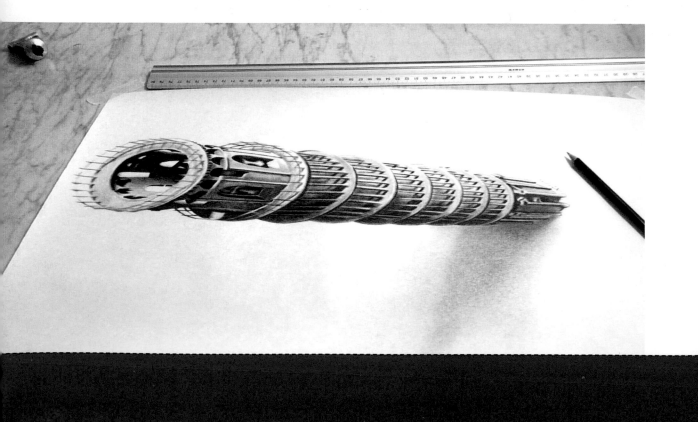

Now your Leaning Tower of Pisa is finished! The lighting in the painting matches the lighting in the room, and the tower's lean looks realistic. Enjoy your three-dimensional view!

JUMPING CHILD

Drawing a portrait can be very challenging for any artist. A person makes a very effective subject for a three-dimensional image as long as you get the techniques right. The two most important things to accomplish are getting the proportions right and creating a painting with the realism of a photo. In this project, you'll paint a jumping boy who should look like he's floating in air rather than standing on the page.

MATERIALS

- Tabloid-sized sheet of paper (11 x 17 inches)
- Pencil
- Oil paints: burnt umber, black, gold ochre, blue, dark blue, Mars brown, and English red
- Small, fine paintbrushes plus a larger one
- Ruler
- Scissors or a retractable knife

DRAWING & POSITIONING

Use the picture on page 106 as a reference for your own painting. Either copy the picture by tracing over it, or try drawing it freehand.

To create an effective 3D painting, the subject must be distorted correctly. In a portrait, the face is the most difficult element to draw.

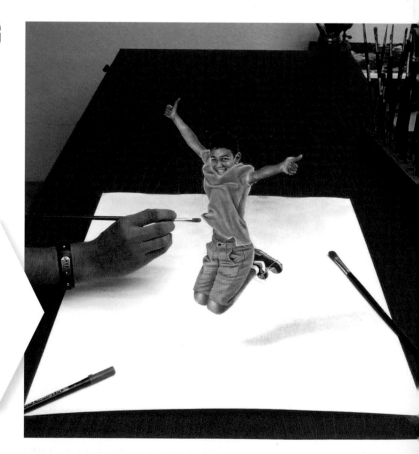

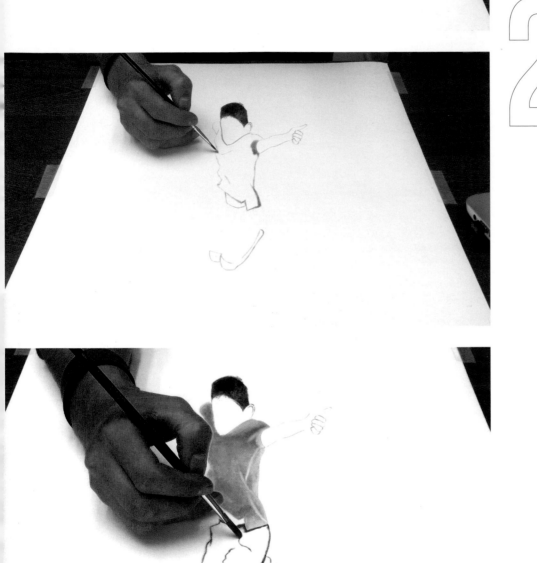

COLORING IT IN

Using a small brush, such as a No. 4, and burnt umber paint, outline the boy's legs, arms, and hands. Paint the boy's hair black, letting some of the white background shine through. Paint his shirt blue, and outline the edge of the shirt with gold ochre. Paint his shorts with gold ochre too, and use the drybrushing technique (see page 16) to let the background shine through. Use darker colors for the shadows and folds on the boy's clothes, and paint his shoes.

MAKE SURE YOU POSITION THE BOY'S LEGS IN THE CENTER OF THE SHEET OF PAPER, WITH HIS HEAD CLOSE TO THE TOP EDGE. THIS WILL HELP YOU LATER ON.

JUMPING CHILD

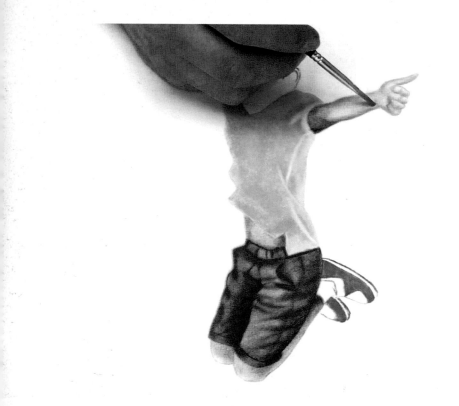

Painting the face requires more detail and precision, but you will still follow the same basic principles. Use the drybrushing technique to paint the boy's face, moving from dark to light.

With a clean brush, combine Mars brown and English red until you've created a mixture that looks like the boy's skin tone. Then, using the drybrushing technique, start by painting the darkest part of the boy's skin with sweeping motions. Use more paint in the shadowed areas, and less in the light areas. This makes the arms and legs look more realistic.

Now step back from the painting, and decide if anything could be improved. If not, move on to page 110.

3 GOING OVER THE BOUNDARIES

The sheet of paper now frames the boy you just painted. If you look at the picture from the side, he should look proportionate, not flat.

Place a ruler just under the boy's shoulders, and draw a line. Cut along this line and around the top part of his body.

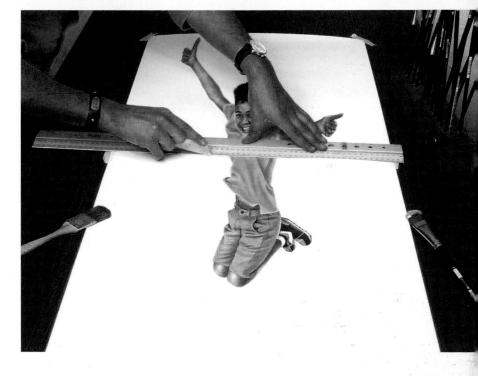

Cutting off the top of the page will trick the eyes further and make the boy look like he's jumping off the page.

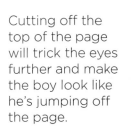

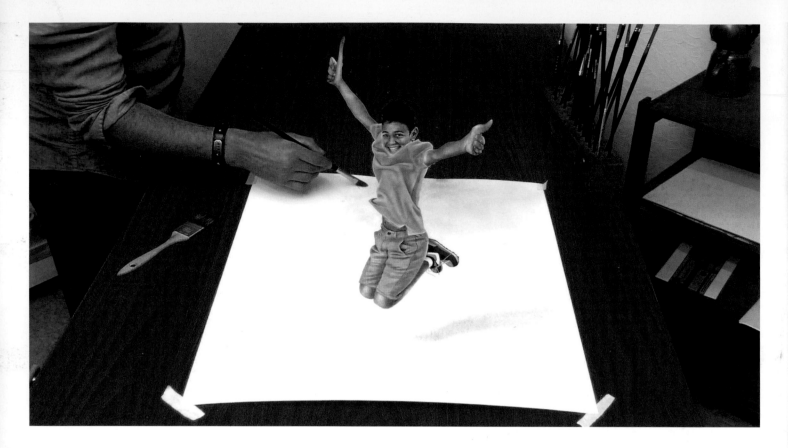

4 | HE'S GROUNDED

When a real-life boy jumps, he casts a shadow. This painting needs a shadow so the boy looks grounded on the page. Because he's jumping, the boy is above the sheet of paper, so his shadow shouldn't start right under his feet.

Use a larger brush, black paint, and the drybrushing technique to paint a realistic-looking shadow. With a light touch, move the brush back and forth, gradually increasing the pressure, to paint the boy's shadow. Paint as evenly as possible. The softer and more even the shadow, the more realistic it will look. Paint under, around, and behind the boy.

WHEN YOU LOOK AT THE PAINTING FROM THE RIGHT PERSPECTIVE, YOU SEE THE BOY IN 3D.

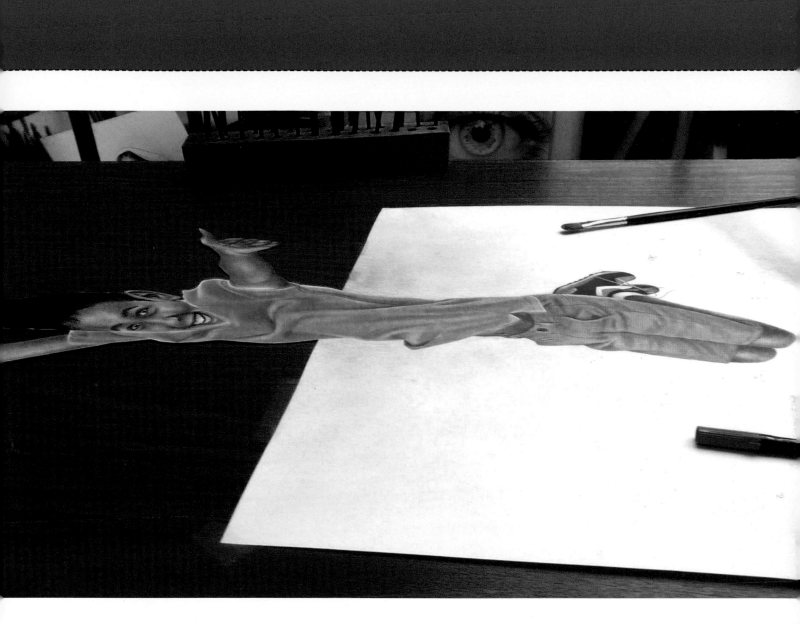

CHANGING YOUR VIEWPOINT
DISTORTS THE SUBJECT.

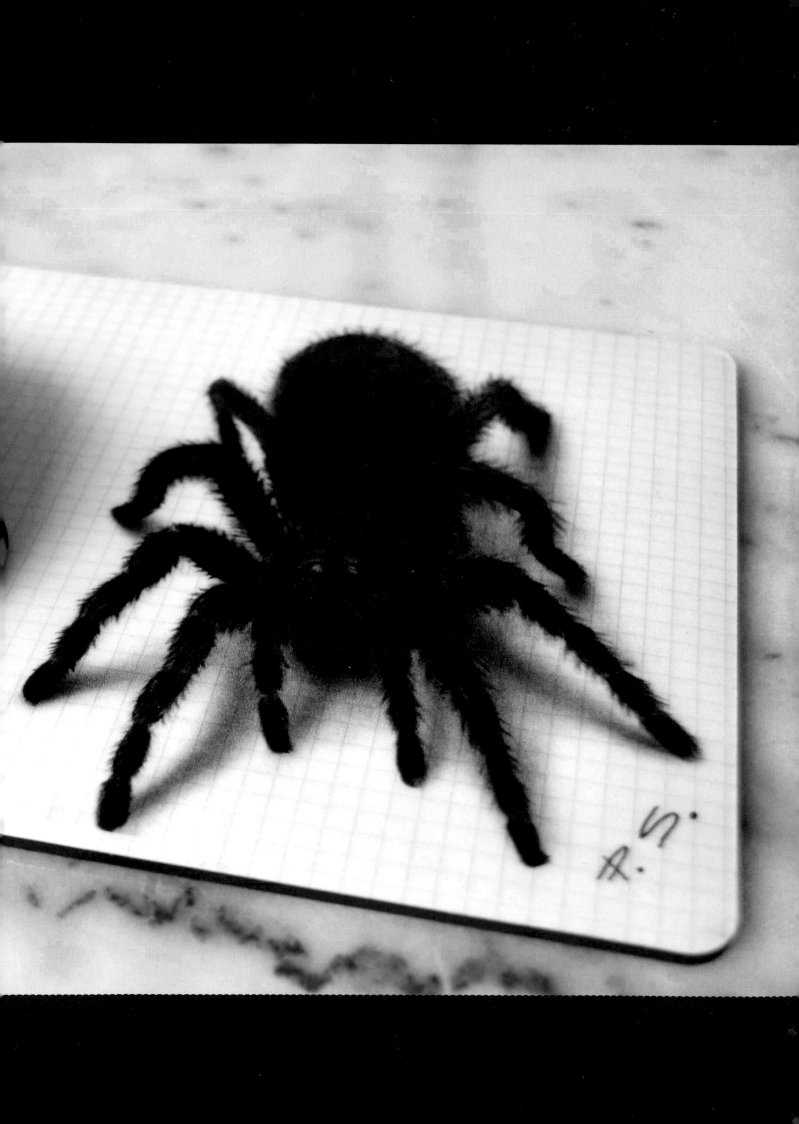

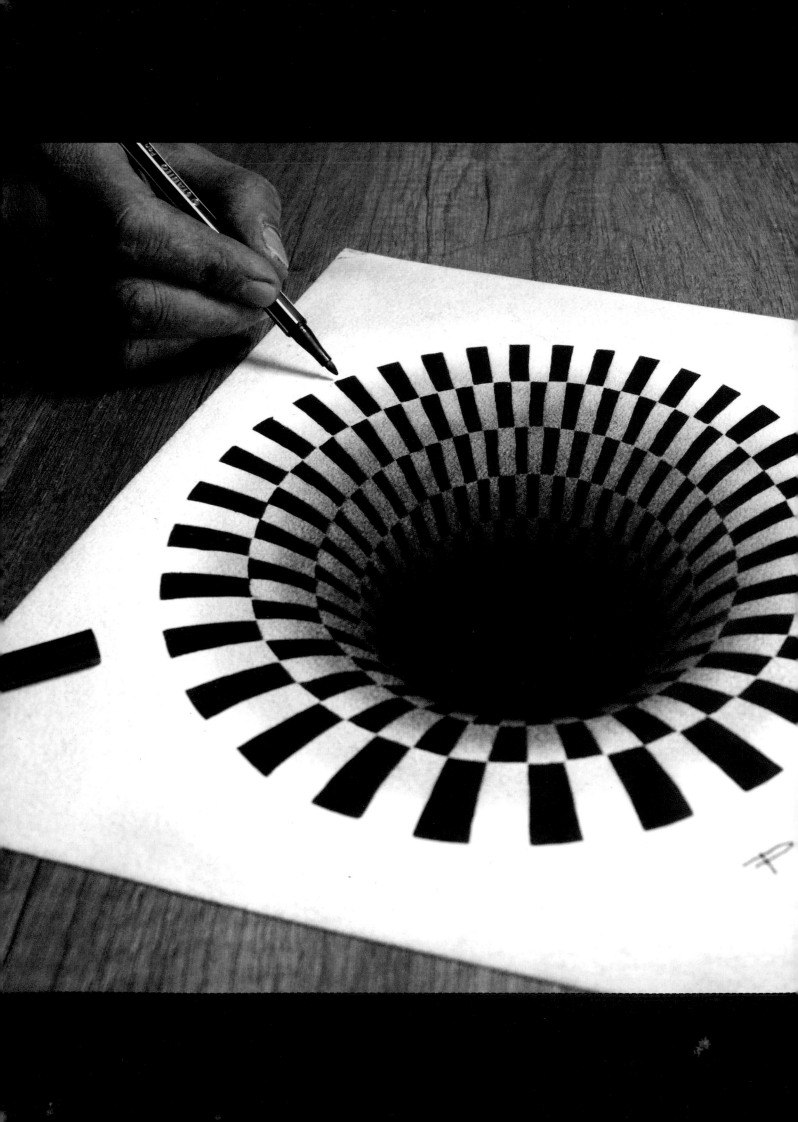

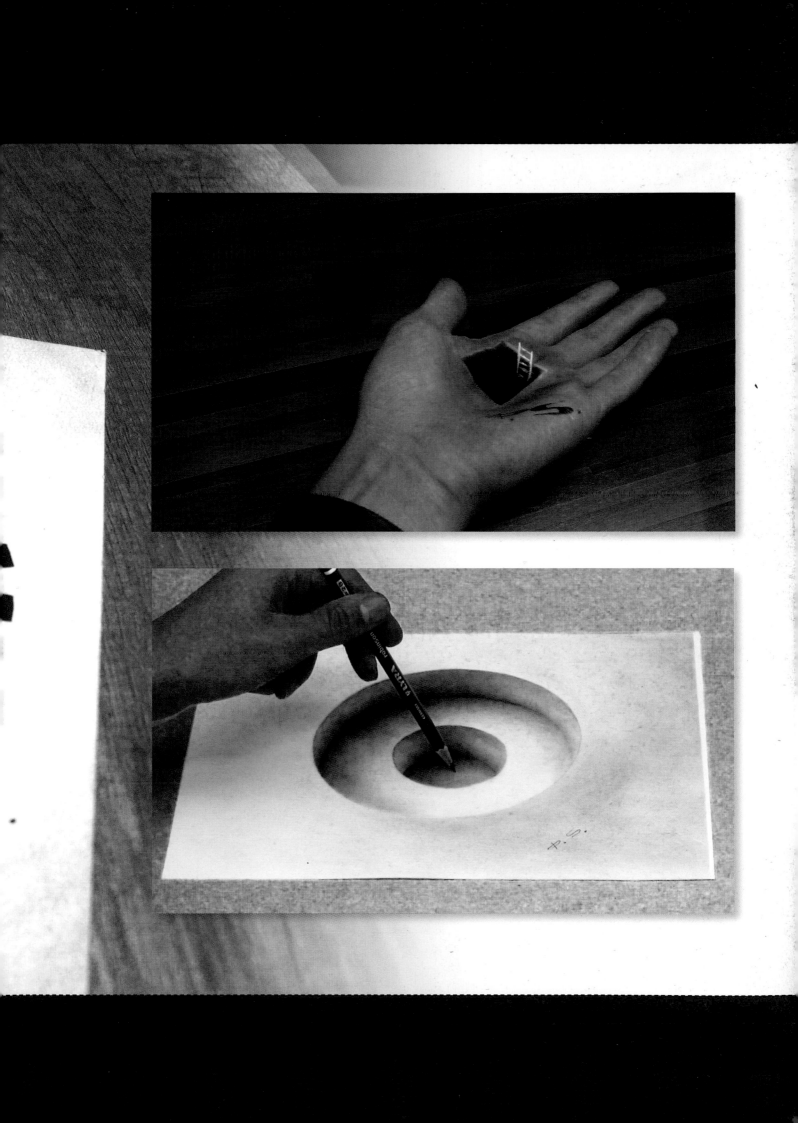

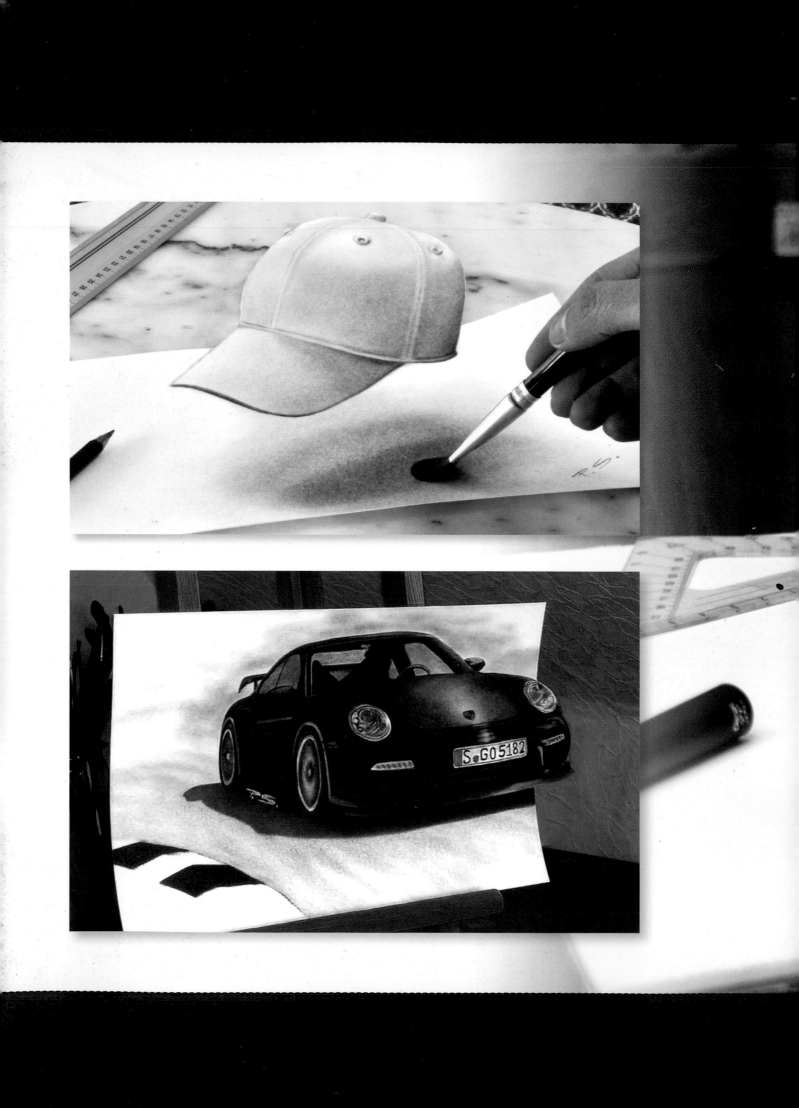

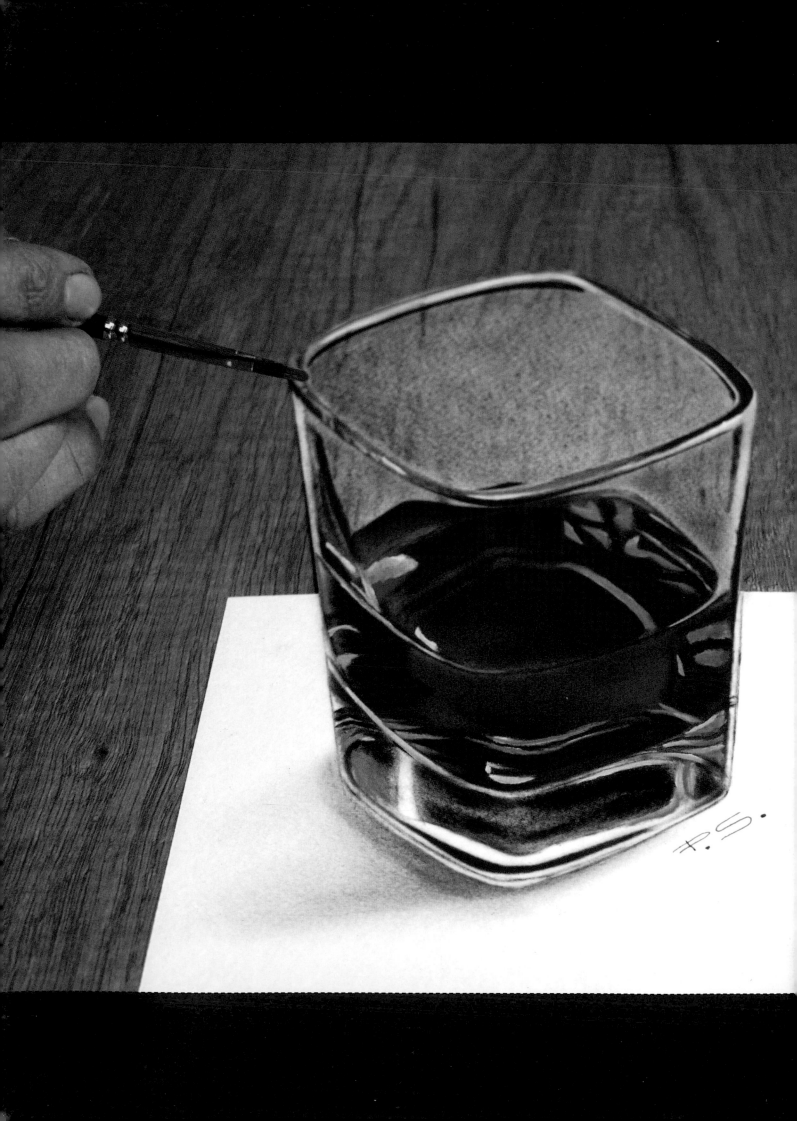

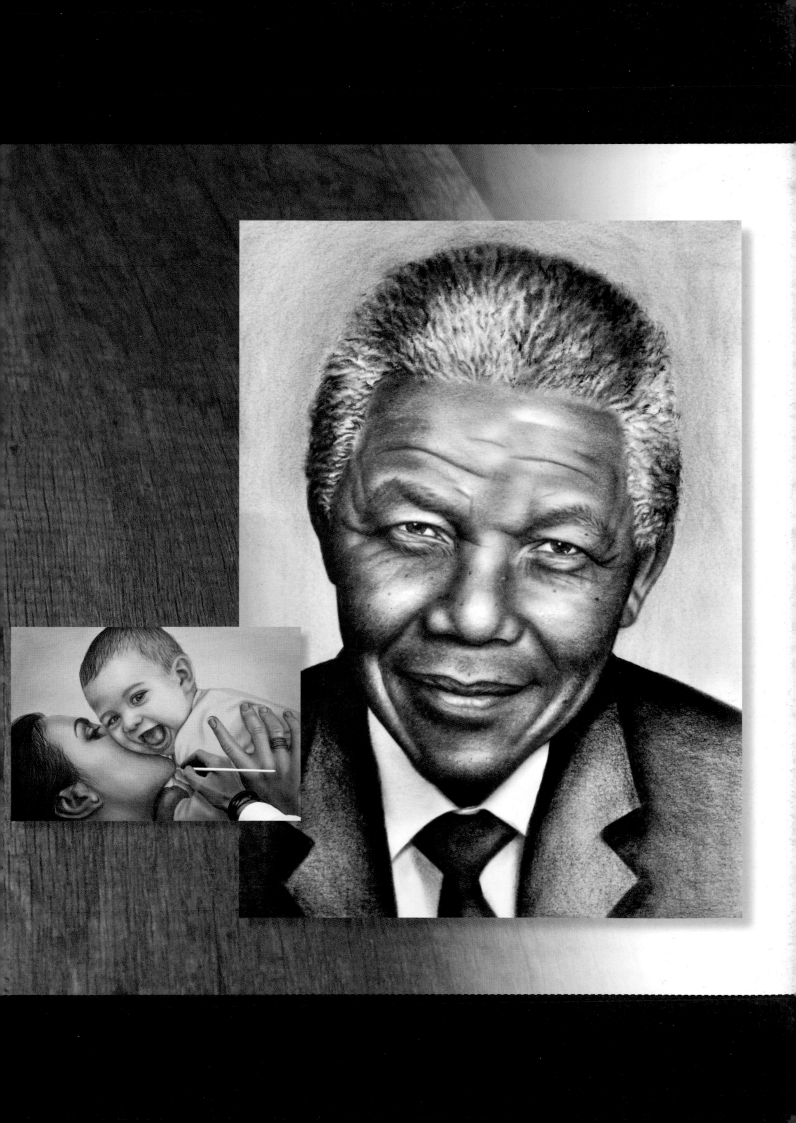

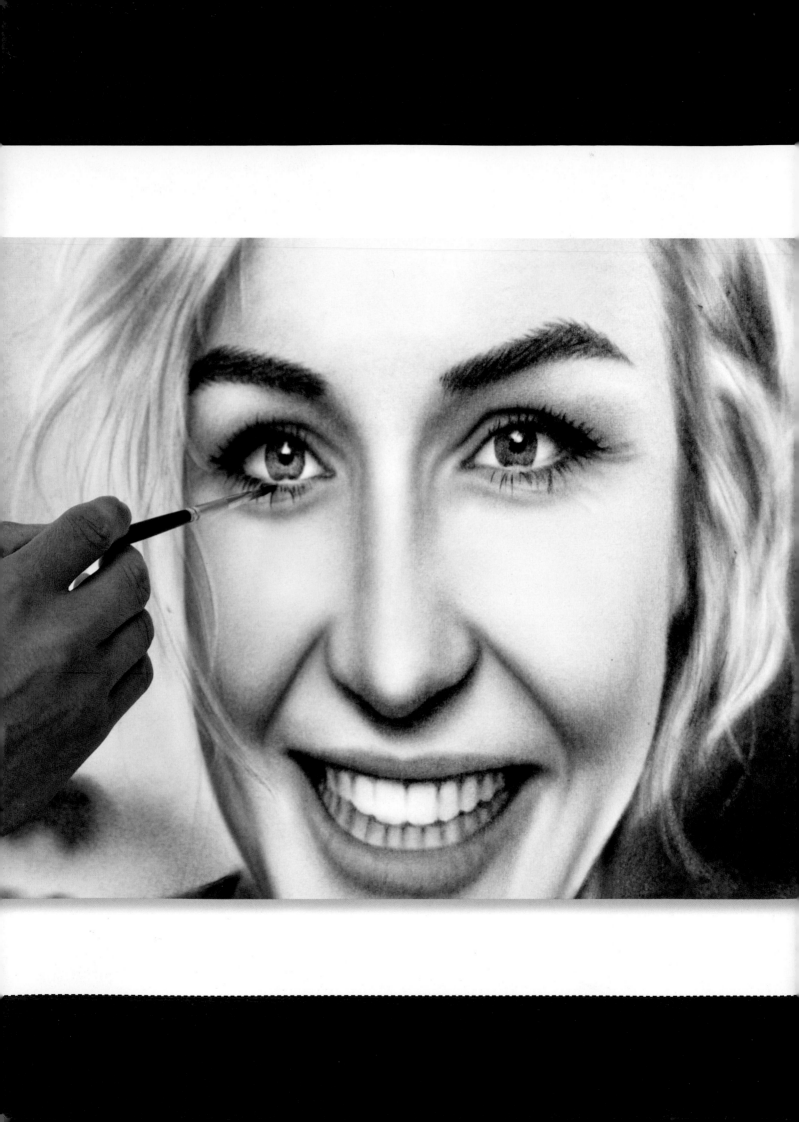

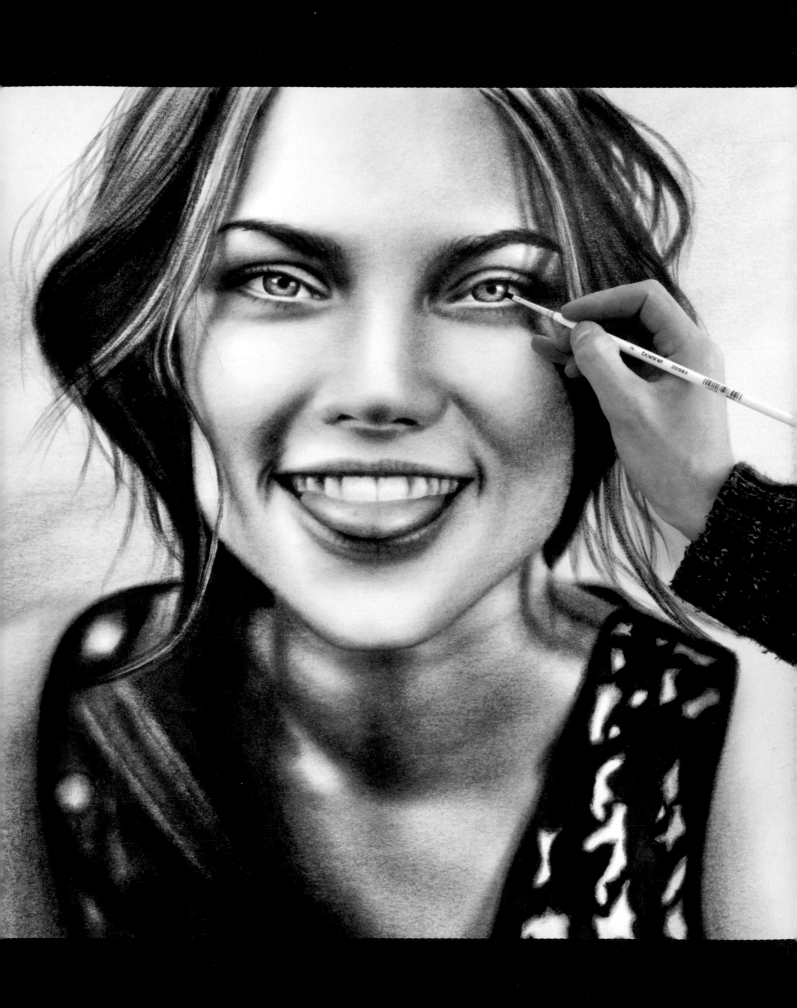

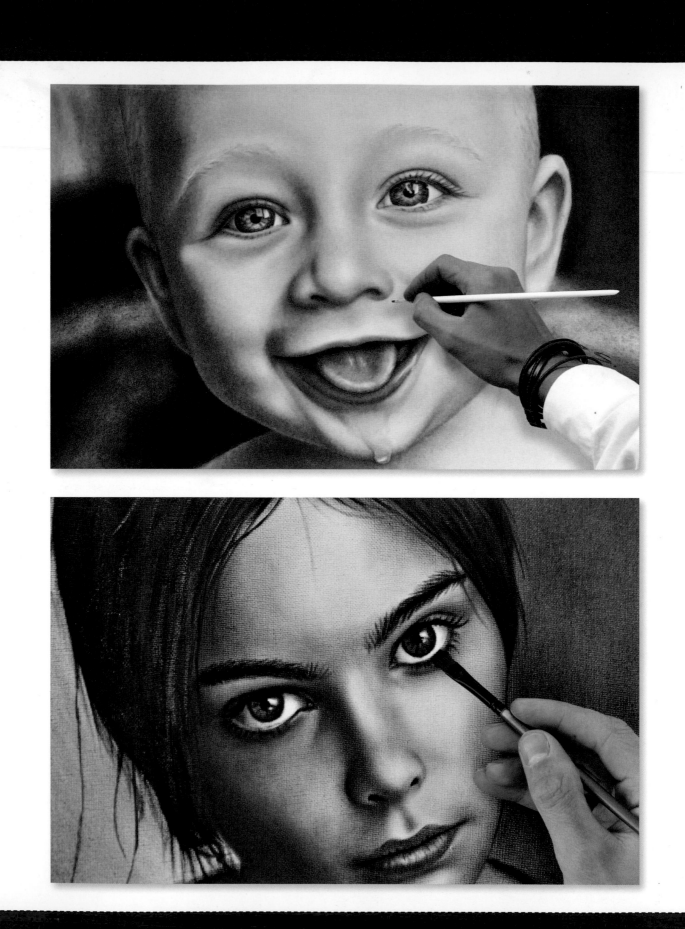

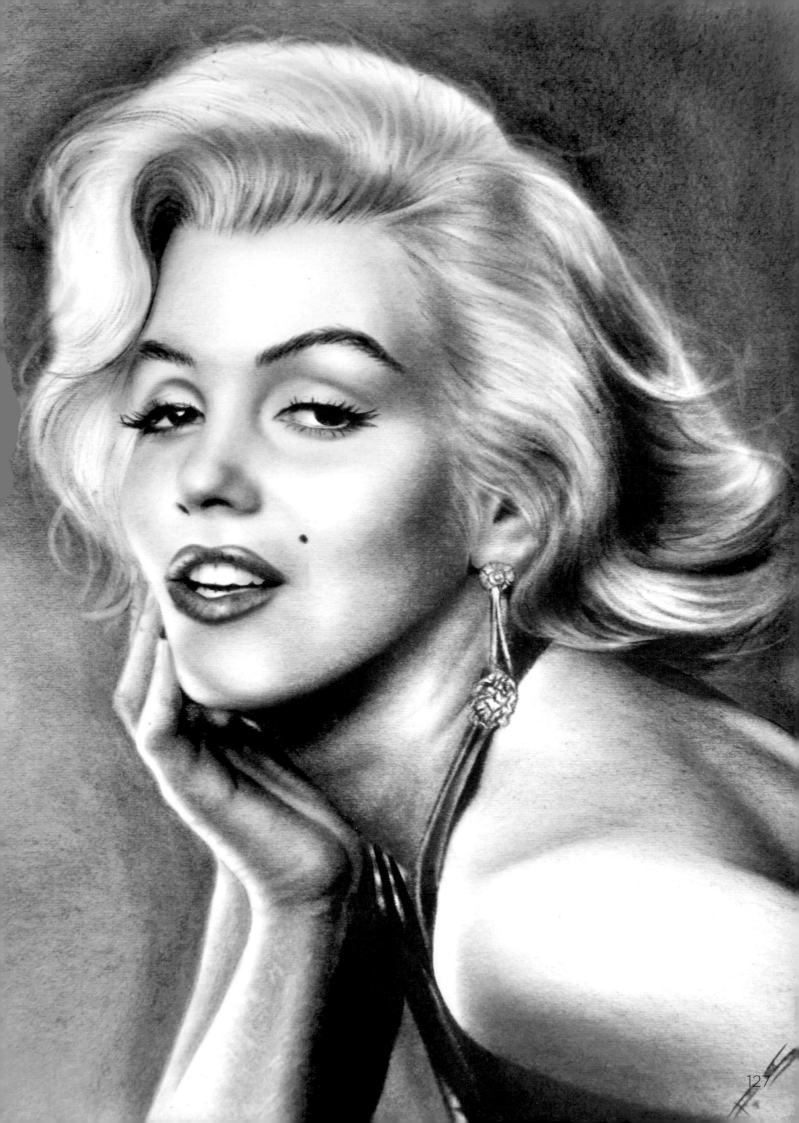

Russian-born artist Stefan Pabst has been painting since he first learned to hold a pencil. As a student, he drew and painted in his schoolbooks. He was inspired by what he saw outside the classroom window, but his favorite subjects were always people.

After finishing school, Stefan moved to Germany, where he joined a youth club. At the clubhouse, Stefan discovered an art studio full of equipment to work with. Within an hour, he'd drawn a three-dimensional skull and learned that he had a passion for creating realistic art. Stefan was soon drawing portraits of his friends, who asked if he would consider turning his hobby into a career. It hadn't yet occurred to him that he could!

In 2007, Stefan placed an ad online, offering to draw people's portraits. To his delight, he was quickly overwhelmed by orders and was able to start his own art business.

Stefan now draws and paints full time from his studio in Minden, Germany. Because of the many questions he receives about his techniques, Stefan posts time-lapse videos on his YouTube channel, where he routinely gets millions of views per video. He's been featured on news programs throughout Europe and China and counts celebrities among his clients. Stefan loves being able to inspire people to paint and is a proud husband and father of three.